IMAGES
of Sports

THE PHILADELPHIA
ATHLETICS

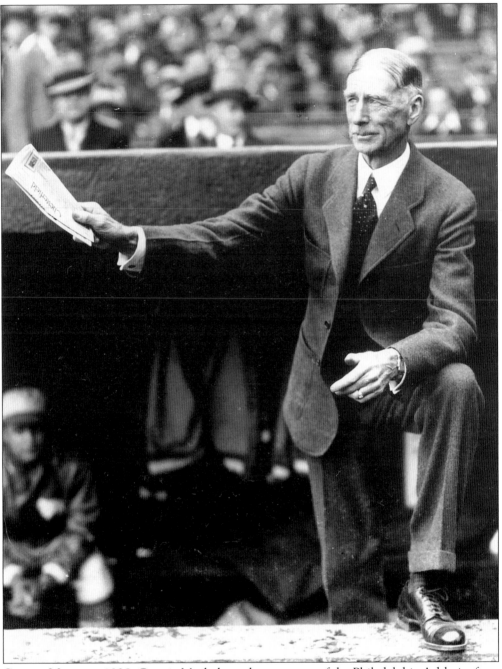

CONNIE MACK, C. 1929. Connie Mack, legendary manager of the Philadelphia Athletics from 1901 to 1950, dressed in a three-piece business suit and adjusted his outfielders by waving his trademark scorecard from the dugout. Known by the sportswriters as the "Tall Tactician" and the "Spindly Strategist," Mack won nine pennants, five World Series, and built two championship dynasties during his half century in the City of Brotherly Love. (National Baseball Hall of Fame.)

IMAGES
of Sports

THE PHILADELPHIA
ATHLETICS

William C. Kashatus

ARCADIA

First published 2002
Reprinted 2003

Published by Arcadia Publishing,
an imprint of Tempus Publishing Inc.
Portsmouth NH, Charleston SC, Chicago,
San Francisco

Printed in Great Britain

Library of Congress Catalog Card Number: 2002110515

For all general information, contact Arcadia Publishing:
Telephone 843-853-2070
Fax 843-853-0044
E-mail sales@arcadiapublishing.com
For customer service and orders:
Toll-free 1-888-313-2665

Visit us on the Internet at www.arcadiapublishing.com

For Ernie Montella and Max Silberman for their love of a game called baseball and their passion for a team called the Philadelphia Athletics.

CONTENTS

ACKNOWLEDGMENTS

Writing a book about the Philadelphia Athletics would be impossible without the active participation of the club's historical society. Founded in 1996 to preserve the memory of Philadelphia's greatest professional sports franchise, the Philadelphia Athletics Historical Society (PAHS) operates a gift shop, library, and museum in Hatboro, Pennsylvania, where visitors can turn the clock back, if only for a brief moment, and learn about the trials and tribulations of Connie Mack's colorful team.

Just as important are the regular conferences, banquets, and informal gatherings the PAHS sponsors. These events give the general public a unique opportunity to meet and hear former major league stars talk about their experiences as well as their views on the changing nature of the national pastime. The PAHS has also partnered with the Pennsylvania Historical and Museum Commission to establish historical markers commemorating the team and its colorful personalities. Finally, the PAHS recommends, annually, a former Athletics star to the Philadelphia Phillies for induction into the Veterans Stadium Wall of Fame. These events are designed to promote an interest in the Philadelphia Athletics and inspire a younger generation of baseball fans.

None of these activities could take place without the remarkable efforts of Ernie Montella and Max Silverman. Both individuals have proven, time and again, that they are the heart and soul of the PAHS, and all of us are deeply appreciative of their efforts.

I have also come to know and admire many other PAHS members. David Jordan, the president, inspired me to write baseball history and even agreed to review my earliest efforts. Bob Warrington, the vice-president, has become a good friend and collaborator on several endeavors, including a six-month exhibition, *Baseball's White Elephants: Connie Mack and the Philadelphia Athletics*, that was sponsored by FOX-TV and held at the Chester County Historical Society in 1999; the Philadelphia Baseball Conference and Memorabilia Appraisal, which ran from 1999 to 2001; and several radio interviews on the old Athletics. Bob also made available his own photo collection for this book and, along with David, reviewed the manuscript for publication.

Other photographs contained in this work come from the collections of Charles Burkhardt, Vergil Dell Angelo, Ed Falvey, Pete Suder, and Rich Westcott as well as those of the *Baltimore Sun*, the National Baseball Hall of Fame Library, the *Philadelphia Inquirer*, and the Urban Archives of Temple University. I am grateful to these individuals and organizations for granting the permission to reproduce their photographs in this book.

Special thanks are extended to Tiffany Howe and the staff at Arcadia Publishing for their editorial counsel; and my wife Jackie, and our sons, Tim, Pete, and Ben, who indulge my enduring passion for baseball.

INTRODUCTION

Philadelphia greeted the 20th century with a surge of cheer and confidence. In 1901, the city's population of nearly 1.3 million was a rich mix of immigrants, natives, and transplants. Each group had its own distinctive and relatively stable neighborhood, connected only by railroad tracks and the brand new trolleys that cut through them. A powerful Republican machine, which had created prosperity and guaranteed progress, dominated the city's political landscape, though graft had become a way of life.

Philadelphia also witnessed substantial economic growth with the expansion of old businesses and the creation of new ones. Industry was the city's backbone, as the clang of the forge and the buzz of factories could be heard across the working class neighborhoods that dotted the downtown and northern quarters. Opportunities abounded for those with entrepreneurial ambitions in the marketing and selling of everything from derbies to chocolates. Into this optimistic, brash, and sooty society stepped Cornelius McGillicuddy, the former manager of the Milwaukee Baseball Club of the recently defunct Western League.

Better known as "Connie Mack," the scrawny six-foot one-inch Irishman looked more like an undertaker than the baseball genius he would soon become. Dressed in a black three-piece suit, complete with necktie, detachable collar, and derby, Mack's appearance suggested that he meant business. Indeed, he did.

Mack, an entrepreneur himself, fit nicely into the rough-and-tumble atmosphere of Philadelphia at the turn of the 20th century. Three enterprising businessmen, Ban Johnson, Charles Comiskey, and Charles Somers, organized a new American League to enter professional baseball as a rival to the National League and persuaded Mack to assume control of the new Philadelphia Athletics franchise.

It was a calculated risk. There was room for competition in major league baseball since the National League teams were losing money at the gate and their owners were divided into two warring camps over players' salaries and other administrative expenses. Mack challenged the older circuit by offering sizeable pay increases to attract National League stars. His greatest catch came from the local Philadelphia Phillies in second baseman Napoleon Lajoie. Infuriated by the conspiracy, Phillies' president John Rogers obtained a court injunction against his former player, forcing him to move on to another team after the 1901 season. Other National League owners and managers joined the fray, condemning Mack for his underhandedness.

John McGraw, manager of the National League's powerful New York Giants, spitefully predicted that the Athletics would become the "White Elephants," or money losers, of the American League. Mack countered by adopting the animal as his team's mascot, attaching a small white elephant on the left breast pocket of each player's uniform. It was an amusing but rather telling action of a man who is considered today the paragon of baseball managers.

Connie Mack's exceptional knowledge of the game, impeccable professional disposition, and extraordinary ability to manage players captured the attention of the baseball world at a time when the game was riddled with scandal, intemperance, and rowdyism. He won nine pennants, five World Series, and built two championship dynasties (1910–1914 and 1929–1931) during

his fifty years as manager of the Philadelphia Athletics. But the reign of the Tall Tactician was not a string of unblemished successes.

The truth is that Connie Mack managed only two kinds of teams during his half-century in the City of Brotherly Love— unbeatable and lousy. His 9 pennants were balanced with 17 last place finishes. What's more, Mack's 3,776 victories as a manager were exceeded only by the 4,025 defeats he suffered, still a record for most losses by a single manager. His careful nurturing of two championship dynasties was matched by his exceptional skill in dismantling two of the greatest teams of all-time, in 1915 and again between 1932 and 1935. But what colorful characters he brought to town!

There were dim-witted roust-a-bouts like Rube Waddell, an eccentric pitcher known for chasing loose women, speeding fire trucks, and unruly fans. "Shoeless Joe" Jackson, who would become the greatest natural hitter in the game before the Black Sox Scandal of 1919 unceremoniously ended what should have been a Hall-of-Fame career, was also discovered by Mack. Baseball immortality was eventually bestowed on others, including second baseman Eddie Collins, considered the most intelligent player in the game during the Dead Ball Era; catcher Mickey Cochrane, a lifetime .320 hitter who was known to respond to a close loss by weeping, pulling his hair, and butting his head against the dugout wall; Jimmie Foxx, an intimidating power hitter known to launch home runs even farther than Babe Ruth; Lefty Grove, a pitcher with 300 career victories who tore through the clubhouse laying waste to lockers, water coolers, and, on occasion, a teammate or two when he lost; and "Bucketfoot Al" Simmons, who could be just as vicious, working himself into a homicidal rage against pitchers before going to bat. Connie Mack's real genius was his ability to harness the aggressive instincts of these and other players, shaping them into a productive team. In the process, the "Spindly Strategist" brought a sense of integrity to a primitive game that became our national pastime.

The Philadelphia Athletics tells the fascinating history of this legendary manager and his colorful teams through more than 160 photographs, many never before published. Photographs tend to be more engaging than the written word because they can recreate the atmosphere of a time period, indicate styles of clothing during a particular era, and even reveal insights into an individual's personality. In this pictorial history, you'll meet ballplayers who were sharp-witted and strong, reckless and carefree, brutally candid and shamelessly self-indulgent. Some will come to you in a studio setting with somber, unsmiling faces. Others are portrayed in their natural element of the ballpark full of unmistakable pride and vigor.

The passage of time is reflected in the changing uniforms and cap styles, from the crème-colored pillbox with dark blue piping of the first championship dynasty to the simple blue cap with a white script letter "A" worn in the team's final years in Philadelphia. A more subtle change can be seen in the faces of the players. Those who played during the early part of the century rose to the majors from a hard life and paid little attention to diet, health care, or physical conditioning. They appear older than their years, or at least more weathered than their successors of the 1930s, 1940s, and 1950s, who seem to radiate greater strength and health.

Only Mack himself seems to remain untouched by the passage of time, at least through his first 40 years at the helm of the A's. He comes to us as a Victorian gentleman dressed in a dark business suit, with a necktie, detachable collar, and black derby or straw skimmer, even in the heat of the summer months. Rarely does he appear on the playing field, preferring to direct the game from the dugout by waving his trademark scorecard to adjust the fielders.

At the same time, The Philadelphia Athletics is also an inspiring story about men who chased after their dreams, caught up with them, and, for a time, lived them. It is a story that reminds us of an earlier, more innocent era when athletes were heroes who spent their summer afternoons playing baseball for little more than a love of the game. It is a poignant story about a manager and a baseball team that were among the greatest of all time.

One

THE WHITE ELEPHANT COMES TO PHILADELPHIA: 1901–1909

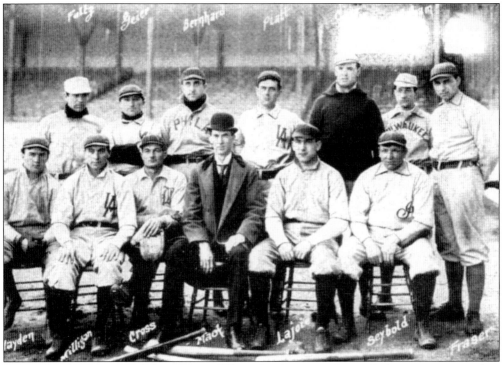

THE 1901 PHILADELPHIA ATHLETICS. When the American League's first season opened in 1901, each of the eight charter teams found themselves infused with talent from the older National League. Not only did Mack land a pitching staff for his Athletics by signing former Phillies Chick Fraser (back row, first from right), Bill Bernhard (back row, third from left), and Wiley Piatt (back row, fourth from left), but also he captured a real prize in the defection of Phillies' second baseman, Napoleon Lajoie (front row, second from right). Although the Chicago White Sox captured the first American League title in 1901, the A's, who finished fourth with a record of 74-62, played the best ball in the league during the final two months of the season. It was a sign of better things to come. (Philadelphia Athletics Historical Society.)

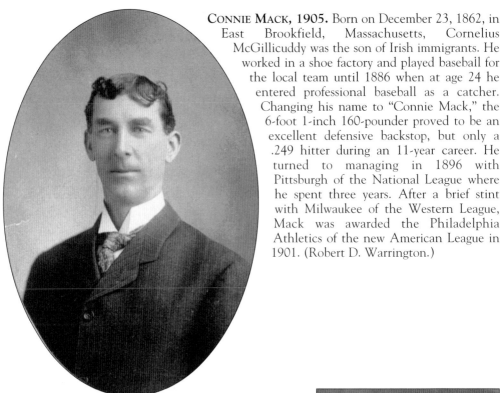

CONNIE MACK, 1905. Born on December 23, 1862, in East Brookfield, Massachusetts, Cornelius McGillicuddy was the son of Irish immigrants. He worked in a shoe factory and played baseball for the local team until 1886 when at age 24 he entered professional baseball as a catcher. Changing his name to "Connie Mack," the 6-foot 1-inch 160-pounder proved to be an excellent defensive backstop, but only a .249 hitter during an 11-year career. He turned to managing in 1896 with Pittsburgh of the National League where he spent three years. After a brief stint with Milwaukee of the Western League, Mack was awarded the Philadelphia Athletics of the new American League in 1901. (Robert D. Warrington.)

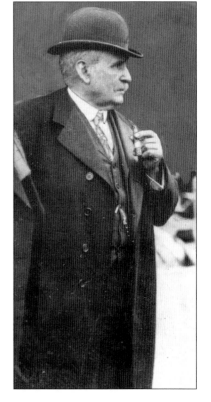

BENJAMIN F. SHIBE. President of Reach Sporting goods, Benjamin Shibe was courted by Mack to invest in his new baseball franchise. After witnessing a capacity crowd at Columbia Park on opening day of 1901, Shibe purchased 50 percent of the club from the original owner, coal baron Charles W. Somers. Mack retained his one-quarter interest, while sportswriters Sam "Butch" Jones and Frank Hough owned the remaining 25 percent. Shibe assumed control of business matters while Mack managed the club on the playing field. By 1902, the total stock value of the Philadelphia Athletics was $50,000. (The *Philadelphia Inquirer*.)

RUBE WADDELL. Led by the pitching of George "Rube" Waddell, the A's captured their first American League championship in 1902. In his rookie season, the colorful Waddell compiled a 24-7 record, 210 strikeouts, and a 2.05 ERA. He would go on to win more than 150 games over the next four seasons. A classic country yokel, Waddell once called in all of his fielders except the first baseman, and made them stand by the pitcher's mound while he struck out the side. Rube was so thrilled with the feat that he turned cartwheels all the way to the clubhouse. (National Baseball Hall of Fame.)

NAPOLEON LAJOIE. After jumping over from the rival Phillies, A's second baseman Nap Lajoie clinched the first American League batting title in 1901 with a .422 average. He also drove in 125 runs and hit 14 homers to capture the Triple Crown. Unfortunately for Mack, it would be Lajoie's only season with the A's until late in his career. When the Phillies obtained an injunction against their former infielder, Lajoie was forced to move on to Cleveland. For the 1902 season, he was unable to play when the Indians appeared in Philadelphia. (Philadelphia Athletics Historical Society.)

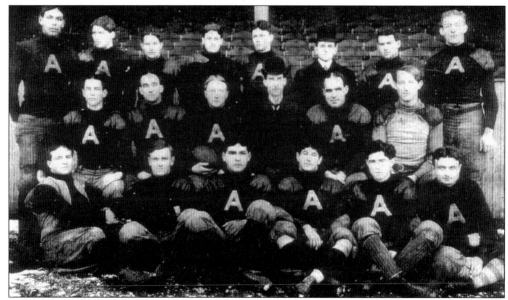

The Athletics Football Team, 1902. Hoping to capitalize on his baseball team's popularity and anticipating the appeal of football as a professional sport, Connie Mack assembled a Philadelphia Athletics Football team for post-season games at Columbia Park. It was not a profitable venture though, and after going $4,000 in the red, Mack decided to stick with baseball. (Philadelphia Athletics Historical Society.)

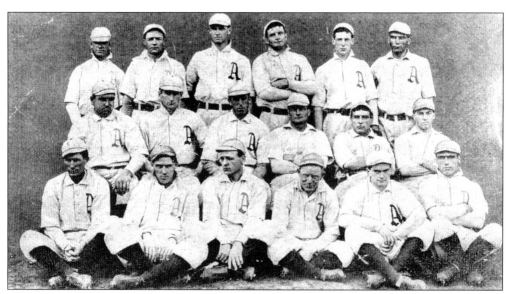

The 1905 American League Champions. Mack's White Elephants won their second pennant in four years, thanks to Harry Davis's (back row, second from left) team-leading .284 average and the brilliant pitching of southpaws Rube Waddell (back row, fourth from left) and Eddie Plank (middle row, third from left). But in the World Series, the National League's New York Giants dispatched the A's in five games. (Philadelphia Athletics Historical Society.)

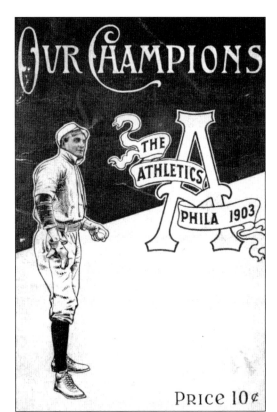

THE 1903 A's YEARBOOK. Sponsored by B.F. Keith's Vaudeville Theaters, the A's 1903 yearbook is one of the earliest of its kind. Rube Waddell graces the cover, while one of the earliest images of the A's White Elephant logo appeared on the back. The yearbook recorded the exploits of the 1902 American League Champion A's. (Robert D. Warrington.)

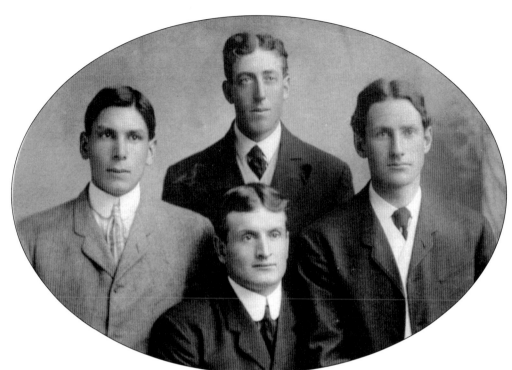

THE 1905 PITCHING STAFF. Having captured their second pennant in four years, Connie Mack chose to have his team recorded for posterity in the more respectable confines of a photographic studio. His pitchers struck an especially sober pose. Above (clockwise from bottom, center) are George "Rube" Waddell (26-11, 287 K, 1.48 ERA); Albert "Chief" Bender (16-11, 142 K, 2.83 ERA); Eddie Plank (25-12, 210 K, 2.26 ERA); and Andy Coakley (20-7, 145 K, 1.84 ERA). To the left is Weldon Henley (4-12, 82 K. 2.59 ERA). (Robert D. Warrington.)

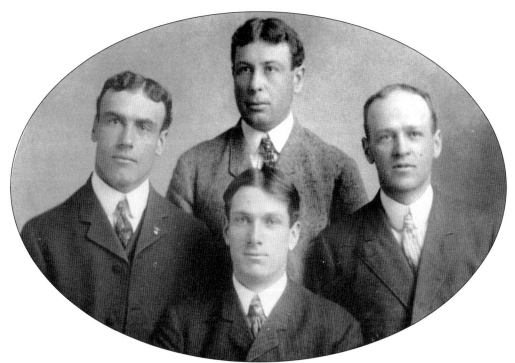

THE 1905 ATHLETICS. The top photo shows (clockwise from bottom, center) outfielder Briscoe Lord (.239); and catchers Mike Powers (.149), Ossie Schreckengost (.272), and Harry Barton (.167). The bottom photo shows (clockwise from bottom, center): Outfielders Socks Seybold (.270), Topsy Hartzel (.276), and Danny Hoffman (.262); and pitcher Jimmy Dygert (1-3, 24 K, 4.37 ERA). (Robert D. Warrington.)

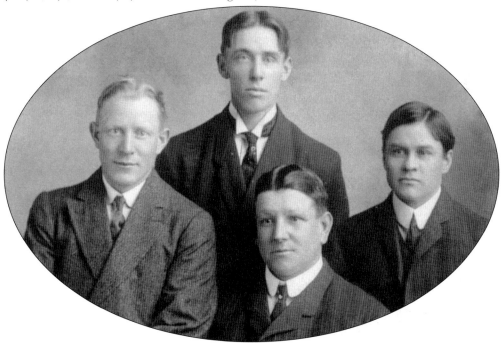

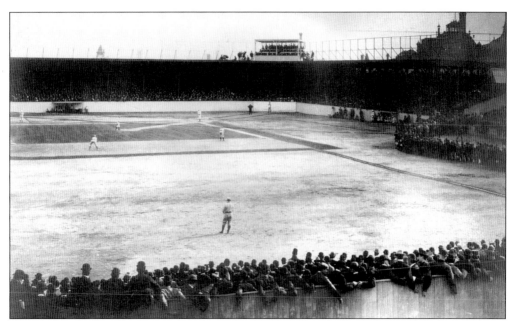

COLUMBIA PARK. The A's first home was Columbia Park located on a site bounded by Columbia Avenue and Oxford Street between Twenty-ninth and Thirtieth Streets in North Philadelphia. A semi-circular, single-decked grandstand bounded the field from first to third, with open bleachers down both foul lines. Players sat on wooden benches in the absence of dugouts. This small wooden stadium only seated 9,500 spectators and was often filled to capacity, especially during the pennant-winning campaigns of 1902 and 1905. (Rich Westcott.)

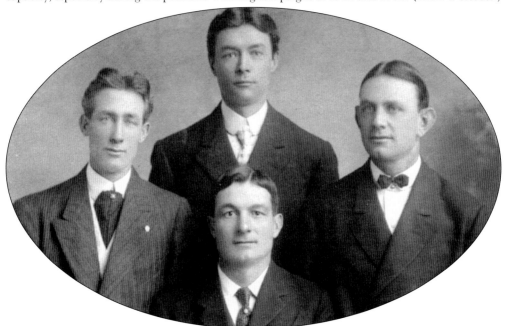

THE 1905 INFIELDERS. This last portrait from 1905 shows (clockwise from bottom, center) third baseman Lave Cross (.266); shortstop Monte Cross (.270); first baseman Harry Davis (.284); and second baseman Danny Murphy (.278). (Robert D. Warrington.)

16

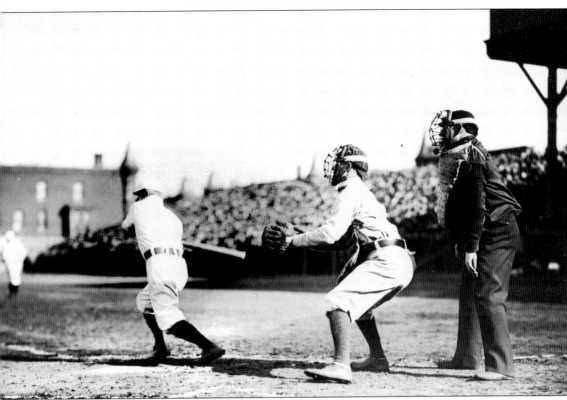

TOPSY HARTSEL. Only five feet five inches in height, Hartsel was an expert at working pitchers for walks. In 1902, the small left fielder led the American League in walks (87), stolen bases (47), and runs scored (109). He also helped the A's win four pennants in his ten seasons with the White Elephants. (Charles Burkhardt.)

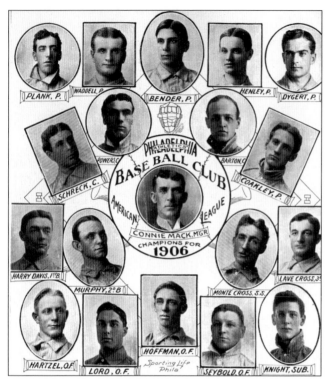

PLANK, P. | WADDELL, P. | BENDER, P. | HENLEY, P. | DYGERT, P.
POWERS, C | BARTON, C
SCHRECK, C. | COAKLEY, P.
CONNIE MACK, MGR.
BASE BALL CLUB
PHILADELPHIA
AMERICAN LEAGUE
CHAMPIONS FOR 1906
HARRY DAVIS, 1ST B. | LAVE CROSS, 3RD
MURPHY, 2° B | MONTE CROSS, S.S.
HARTZEL, O.F. | LORD, O.F. | HOFFMAN, O.F. | SEYBOLD, O.F. | KNIGHT, SUB.
Sporting Life Phila

THE PHILADELPHIA ATHLETICS, 1906. After capturing pennants in 1902 and 1905, *Sporting Life Magazine* predicted that Connie Mack's A's would repeat as American League champions in 1906. Instead, the White Elephants dropped to fourth place with a 78-67 record. Harry Davis (.292, 12 HR, 96 RBIs), Danny Murphy (.301, 2HR, 60 RBIs), Socks Seybold (.316, 5 HR, 59 RBIs), and pitcher Eddie Plank (19-5, 108 K, 2.25 ERA) were the only bright spots on a team that finished 12 games behind the pennant-winning Chicago White Sox. (Philadelphia Athletics Historical Society.)

HARRY DAVIS. A native of Philadelphia, Harry Davis was named the first captain of the A's and managed the team whenever Connie Mack was absent. Davis was also a prodigious slugger. For four straight years, from 1904 through 1907, he led the American League in home runs. Only Babe Ruth, Frank "Home Run" Baker, and Ralph Kiner matched the feat. Davis also led the league in doubles in 1902, 1905, and 1907, and in RBIs in 1905 and 1906. He remained with Connie Mack as a player, coach, and scout until 1927. (Charles Burkhardt.)

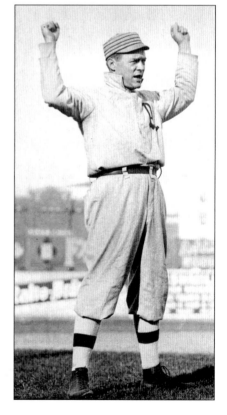

DANNY MURPHY. In his July 8, 1902 debut, second baseman Danny Murphy went six for six, including a home run, and immediately became a fan favorite. His .313 average helped the A's to their first pennant that year. Offensively, Murphy was brilliant, hitting .300 four times as a regular and twice more as a utility player. But he was only a fair fielder, and Mack, in 1908, was forced to switch him to the outfield to make room for future Hall-of-Famer Eddie Collins. (Charles Burkhardt.)

THE 1909 OUTFIELD PROSPECTS. After a sixth-place finish in 1908, Mack decided to rebuild his team. Among the young talent were, from left to right, Amos Strunk, Heinie Heitmuller, and "Shoeless Joe" Jackson. While Strunk became a reliable outfielder, Heitmuller and Jackson never realized their talents in Philadelphia. Jackson's case was especially tragic. An illiterate southerner, he was ignorant of city ways and was mocked by his teammates. Mack traded him to Cleveland for Bris Lord in 1910. Jackson blossomed into a great hitter over the next decade with both the Indians and Chicago White Sox. Accused of throwing the 1919 World Series along with seven of his White Sox teammates, Jackson, at the age of 31, was banished forever from baseball. He had compiled a lifetime batting average of .356. (Philadelphia Athletics Historical Society.)

RUBE OLDRING. Another Philadelphia native, Rube Oldring began his Athletics career in 1906. His excellent speed, strong arm, and instinctive play made him exceptionally valuable in the outfield. Only a .270 lifetime hitter, Oldring didn't have much power, but his brilliant defense earned him Mack's gratitude when he made a diving catch to stave off a Giant rally in the 1913 World Series. The Tall Tactician would later select Oldring as the center fielder on his all-time Athletics team. (Philadelphia Athletics Historical Society.)

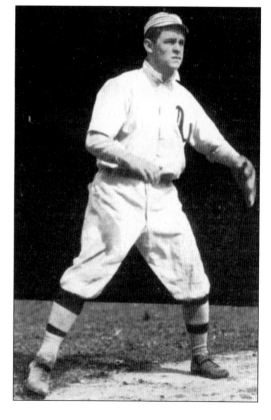

JOHN "STUFFY" MCINNIS. A product of the Boston semi-professional leagues, John McInnis earned the nickname "Stuffy" for his spectacular defensive play that elicited shouts of "That's the stuff, kid!" He began his Athletics career as a shortstop in 1909. Two years later, he would replace Harry Davis as the A's first baseman. His acrobatic style and brilliant defense made him an anchor of the famed "$100,000 Infield" of Mack's first championship dynasty. (Philadelphia Athletics Historical Society.)

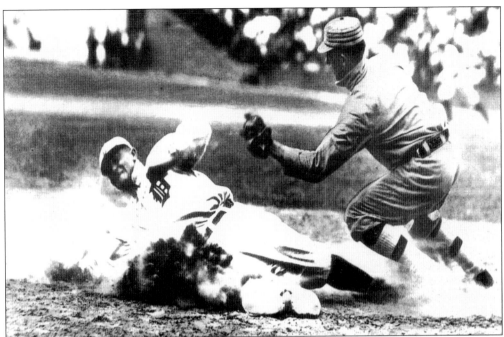

COBB SPIKING BAKER, 1909. The Athletics, in a rebuilding process, were expected to dwell in the second division during the 1909 season. Surprisingly, they held on to first place for most of August before the champion Detroit Tigers unseated them. During that series, Ty Cobb, the Tigers' volatile star outfielder, spiked the A's Frank "Home Run" Baker on a steal of third base. Cobb, who was known to sharpen his spikes prior to game time, was called a "back-alley artist" by Mack because of the incident. A's fans were more subtle, sending the Detroit outfielder anonymous death threats. Cobb required his own entourage of policemen whenever he appeared in Philadelphia after that and until he signed to play for the A's in 1927. (Philadelphia Athletics Historical Society.)

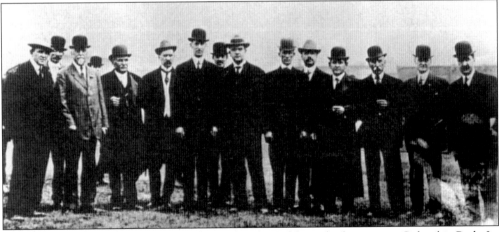

GROUNDBREAKING FOR SHIBE PARK. By 1908, the Athletics had outgrown Columbia Park. Its limited seating capacity of 9,500 left thousands of fans standing outside the gates. In a quest to secure higher profits, Ben Shibe, principal owner, made plans for a new ballpark. On April 13, 1908, Shibe (third from left) and Connie Mack (sixth from left) held a groundbreaking ceremony. (Rich Westcott.)

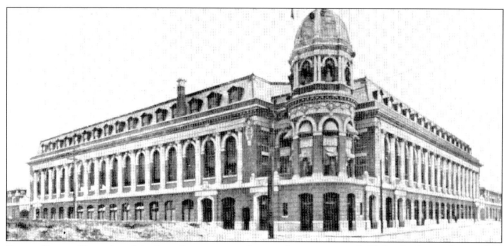

Shibe Park. Completed in less than a year, the newly constructed Shibe Park was located at Twenty-first Street and Lehigh Avenue in the heart of North Philadelphia. The handsome facility was the first steel and concrete stadium in the nation and gave the appearance of a French Renaissance castle. Its two grandstand walls were joined at Twenty-first Street and Lehigh Avenue where the domed tower of the main entrance stood. Originally, the field dimensions were 378 feet from home plate down the left-field line, 515 feet to center, and 340 feet down the right field line. The park had a seating capacity of 23,000, and an additional 10,000 fans could stand behind ropes on the banked terraces in the outfield. The inaugural game was played on April 12, 1909, before a crowd of 30,162, the largest ever to watch a baseball game up to that point. The A's beat the Boston Red Sox 8-1. (National Baseball Hall of Fame.)

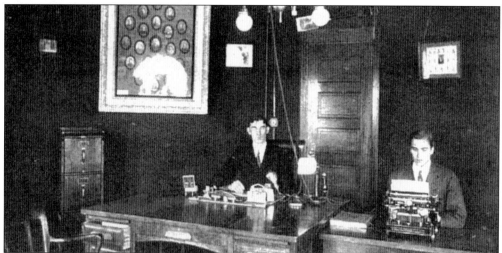

Connie Mack's Office. Connie Mack's office was his personal sanctuary. Located in the top level of the Shibe Park tower, it was furnished with two heavy oak desks, leather-upholstered chairs, and thick green burlap wall coverings, from which hung photographs of his various teams. Access came via a narrow runway from the upper pavilion, aptly called the "Bridge of Hope." Mack would arrive at his office each morning around 9:00 a.m. to open mail, receive visitors, and give dictation. As he grew older, he also took a one-hour nap, reclining on a sizeable sofa that was added. At 2:45 p.m., the Tall Tactician left to prepare for the day's game. (Philadelphia Athletics Historical Society.)

Two

A Tarnished Dynasty: 1910–1915

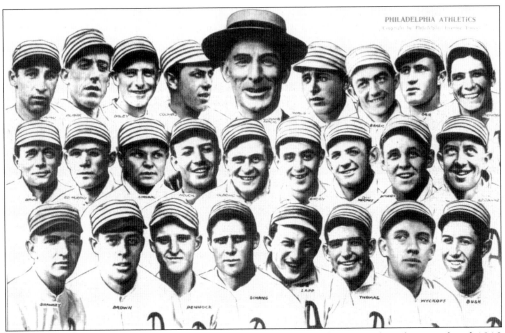

The First Championship Dynasty. Connie Mack's first championship dynasty dated 1910 to 1914. During that span, the "Mackmen" captured three world championships (1910, 1911, and 1913) and four American League pennants. For five years, the A's were almost unbeatable. Mack credited their success to team chemistry. "We're like a happy family, win or lose," he said. Whether they were collegians like Eddie Collins, Jack Barry, Eddie Plank, and Jack Coombs, or less refined personalities like Frank "Home Run" Baker, Amos Strunk, and Stuffy McInnis, Mack capitalized on their talent to mold them into the sport's first championship dynasty ever. (Philadelphia Athletics Historical Society.)

THE "$100,000 INFIELD," PLUS ONE. The heart of Mack's first championship dynasty was the famed "$100,000 Infield," a term which captured the financial value of the four players who composed it. Pictured, from left to right, are Stuffy McInnis, a fine defensive first baseman who is credited as the inventor of the "knee reach;" second baseman Danny Murphy; third baseman Frank "Home Run" Baker, the premier power hitter of the Dead Ball Era; shortstop Jack Barry; and Eddie Collins, an extraordinary base runner and consistent .300 hitter whose performance would, by 1909, force Murphy into the outfield as he took over second base. (National Baseball Hall of Fame.)

EDDIE COLLINS. Connie Mack liked intelligent players. He recruited half of his famed $100,000 Infield from the college ranks, and second baseman Eddie Collins of Columbia University would become the cornerstone of his championship team. When he debuted with the A's in 1906, the 19-year-old Collins used the pseudonym of "Sullivan" because he had a year to complete at Columbia. His aggressive, confident manner earned him the nickname "Cocky," and to be sure, Collins had much to be cocky about. For 10 seasons he batted more than .340. An extraordinary base runner, he led the American League in stolen bases 4 times, his highest season totaling 81 in 1910, a feat that was celebrated by the drawing of the caricature below. What's more, Collins had a way of getting on base. He served as Mack's number two hitter in the line-up and drew 60 to 199 walks a year, giving him an exceptional on-base percentage of .400 in his 8 seasons with the A's. (Top photograph: National Baseball Hall of Fame; bottom photograph: Robert D. Warrington.)

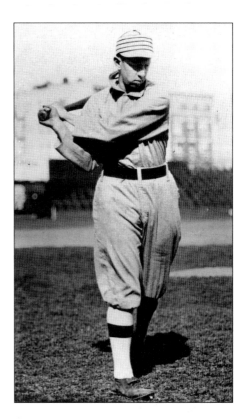

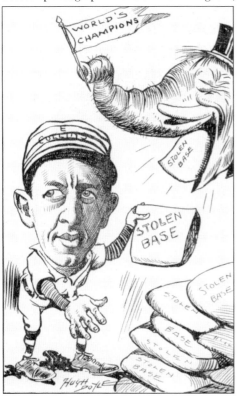

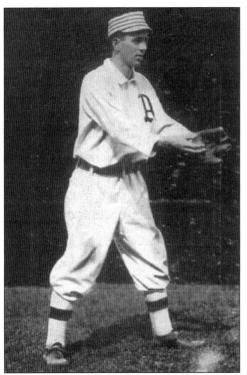

JACK BARRY. The other half of Mack's keystone was Jack Barry of Holy Cross College. The 5-foot 9-inch, 150-pound shortstop stole a career-high 30 bases in 1911 and hit .368 in the World Series. In 1912, he led American League shortstops in double plays. His best season came in 1913 when he enjoyed a career-high .275 batting average and 85 RBIs. (Philadelphia Athletics Historical Society.)

THE 1911 BASEBALL WRITER'S DINNER PROGRAM. This is the program cover from the 1911 dinner hosted by the A's for the Baseball Writers Association of America at New York's Hotel Astor. The dinner celebrated the A's 1911 World Series victory. (Robert D. Warrington.)

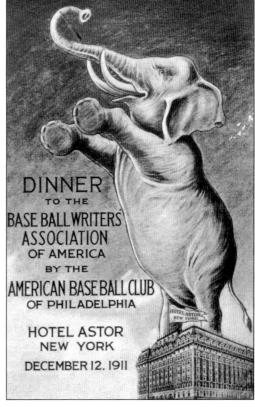

DINNER
TO THE
BASE BALL WRITERS'
ASSOCIATION
OF AMERICA
BY THE
AMERICAN BASE BALL CLUB
OF PHILADELPHIA

HOTEL ASTOR
NEW YORK
DECEMBER 12. 1911

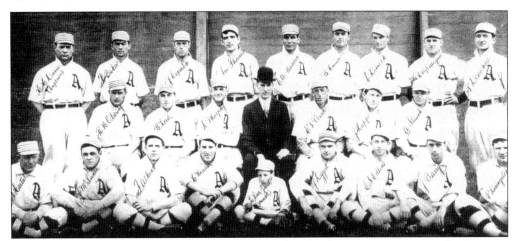

THE 1910 ATHLETICS. When President William H. Taft opened the 1910 season by throwing out the first ball in a game between the Washington Nationals and the Philadelphia Athletics, he introduced a custom that would mark baseball as the official national pastime. Unfortunately, the A's were blanked 1-0. But the White Elephants rebounded to play winning ball all year, capturing their first pennant in five years and defeating the Chicago Cubs four games to one in the Fall Classic. Some of their luck was attributed to a small hunchback, Louis Van Zelst (seated in front of Connie Mack), who was the A's mascot. After being discovered by Eddie Collins in the spring of 1910, Van Zelst won over the hearts of the fans and the superstitious ballplayers who rubbed his back for good luck. He remained the team's mascot through the 1915 season. (National Baseball Hall of Fame.)

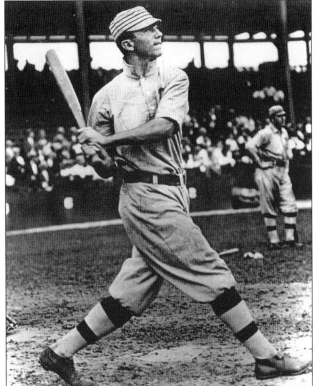

FRANK "HOME RUN" BAKER. The premier power hitter of the Dead Ball Era, Frank Baker anchored the A's infield from 1909 to 1914 at third base. He led the American League in homers for four straight seasons (1911–1914). Swinging a 52-ounce bat, Baker compiled a .334 average, a league-leading 11 home runs, and 115 RBIs in 1911. He repeated as the American League RBI king in 1912 with 133, and again in 1913 with 126. (Philadelphia Athletics Historical Society.)

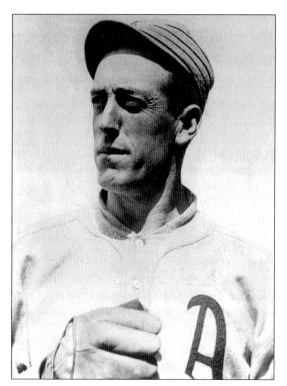

EDDIE PLANK. Named "Gettysburg Eddie" after his central Pennsylvania hometown, Eddie Plank was a mainstay of the pitching staff for Mack's first championship dynasty. Joining the A's in 1901, he posted 17 victories in his rookie year and went on to win 20 or more during each of the following four seasons. From 1910 to 1915, he added another 97 wins, securing himself a place in the Hall of Fame. However, Plank had hard luck in the World Series, posting a 2-5 record during his years in Philadelphia. (Philadelphia Athletics Historical Society.)

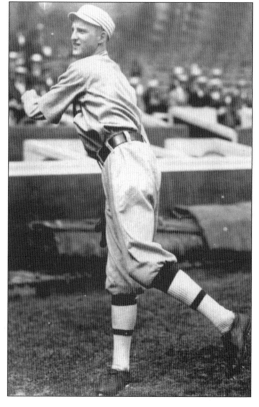

HERB PENNOCK. Raised in a strict Quaker family, Herb Pennock attended the Westtown School in Chester County, Pennsylvania, where he quickly demonstrated a talent for baseball. Originally a first baseman, he became a pitcher, refining his skills on several semi-professional teams. A graceful hurler who performed with an effortless, unvarying motion, Pennock was only 18 when he joined the A's in 1912. Under Mack's tutelage, he steadily improved until he was waived to the Boston Red Sox in 1915. Pennock finally hit his stride when he joined the New York Yankees in 1923. There he became a mainstay on the pitching staff. (National Baseball Hall of Fame.)

"CHIEF" BENDER. Charles Albert "Chief" Bender was a Chippewa Indian who grew up on a reservation, and later, at age 13, attended the Carlisle Indian School in Pennsylvania. When he came to the Athletics in 1903, Bender's Native American background made him a novelty, but his pitching ability made him a star. His most productive year came in 1910 when he posted a 23-5 record, including a no-hitter against Cleveland, and earned the victory in the deciding game of the World Series. Bender's 6-4 career World Series record included nine complete games. (National Baseball Hall of Fame.)

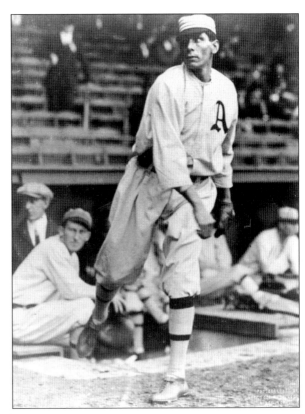

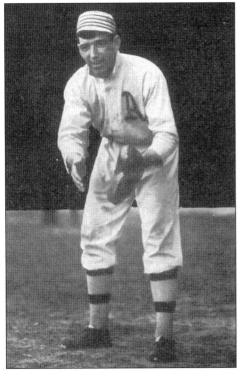

IRA THOMAS. One of Connie Mack's personal favorites, Ira Thomas, at 6 feet 2 inches tall and 200 pounds, was a big, lumbering catcher. Only in 1911 did he catch as many as 100 games, being platooned with Jack Lapp. (Philadelphia Athletics Historical Society.)

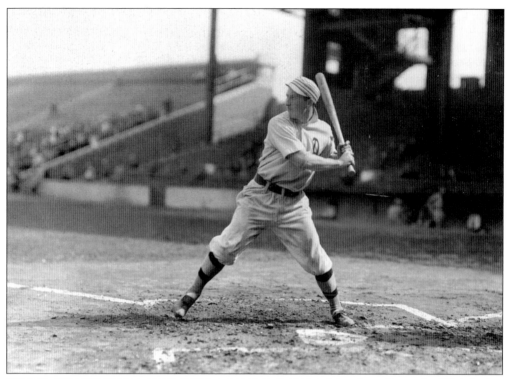

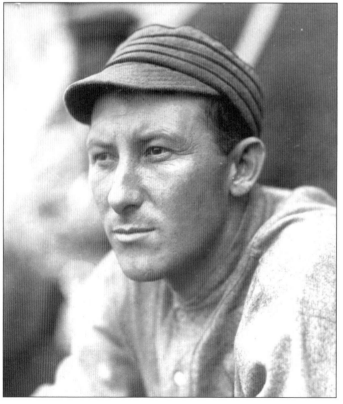

JACK LAPP. In 1911, Jack Lapp was the top hitting catcher in the American League with a .353 mark in 68 games. He platooned with Ira Thomas on four of the A's pennant winning teams.(Charles Burkhardt.)

AMOS STRUNK. An outfielder highly regarded for his defensive skills, Amos Strunk came to the A's in 1908. Because he proved to be a solid left-handed hitter who rarely struck out, Mack made him a regular in 1912. Strunk led American League outfielders in fielding average five times and played in four World Series with the A's before being obtained by the Red Sox in 1918. (Charles Burkhardt.)

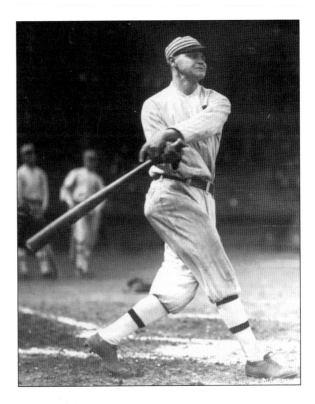

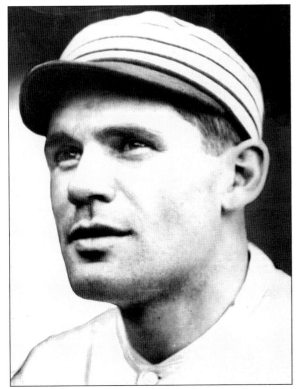

EDDIE MURPHY. A native of Pennsylvania's anthracite coal region, Eddie Murphy began his career as a catcher for the A's in 1912. A year later, Mack converted him to the outfield, where he was a regular for the 1913 and 1914 pennant winners. Traded to the Chicago White Sox in 1915, Murphy became a utility player. He led the American League with eight pinch hits in 1919 as an honest member of the infamous Black Sox, the team accused of throwing the World Series that year. (Charles Burkhardt.)

CONNIE MACK. When his Athletics failed to turn a profit in 1914—despite winning its fourth pennant—Connie Mack believed that the Philadelphia fans had become too complacent with winning. The A's, who walked away with the pennant, were expected to sweep the Boston Braves in the World Series. Instead, the Mackmen were swept four games to none. Rumors circulated that the A's had thrown the series. With many of his star players threatening to jump to the new Federal League, which was offering higher salaries, Mack broke up his team. Albert "Chief" Bender, Eddie Plank, and Jack Coombs were released; Eddie Collins and Jack Barry were sold to other teams in the circuit to keep the American League intact. Frank "Home Run" Baker sat out the 1915 season in a salary dispute with Mack and was later sold to the New York Yankees. The A's would not win another pennant for 15 years. (National Baseball Hall of Fame.)

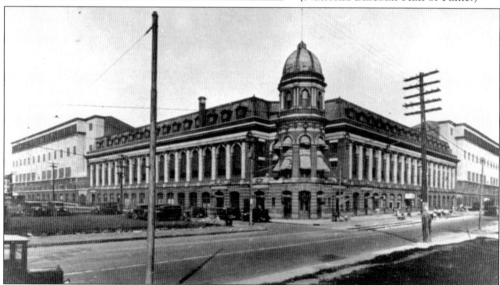

SHIBE PARK, C. 1926. Significant alterations were made to Shibe Park in 1925 to accommodate the A's growing fan base. All single-decked stands were converted into covered double-decks, which now enclosed the entire playing field except for right field. While the renovations decreased the park's dimensions to 334 feet from home plate down the left field line, 468 feet to center field, and 331 feet down the right field line, the total seating capacity increased to 33,500. (National Baseball Hall of Fame.)

Three
REBUILDING: 1916–1928

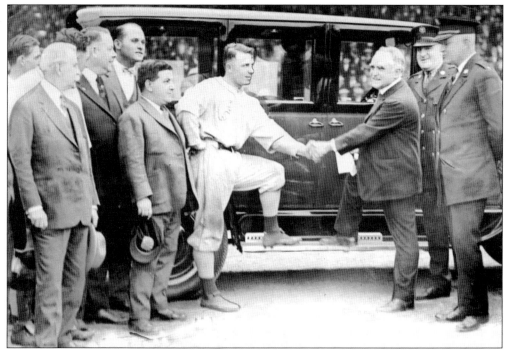

JIMMY DYKES, A'S 1924 MOST VALUABLE PLAYER. Signed by Connie Mack in 1918, infielder Jimmy Dykes proved to be a mainstay of the A's rebuilding process. The native Philadelphian was the club's most reliable player, averaging 125 games through 13 full seasons in Philadelphia. In 1924, he played second, third, and shortstop, compiling a .312 batting average, and was named the team's most valuable player. (Charles Burkhardt.)

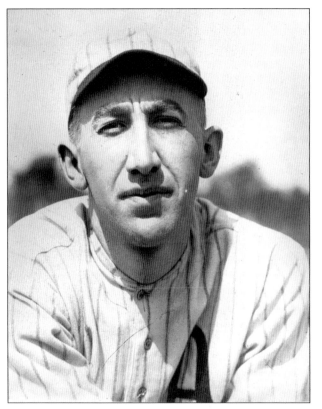

ELMER MEYERS. "I am broke financially but full of ambition," insisted Connie Mack in 1916. "It's like starting all over again for me. I love baseball, and I love to build up teams. I have done it once, and I will do it again." Unfortunately, Mack had to start at rock bottom. His 1916 club dropped 117 games and is still widely regarded as the worst team to have played the game. The A's finished in the cellar for the next five seasons. Among the more forgettable names on those teams was pitcher Elmer Meyers, who lost a total of 55 games for the A's between 1916 and 1919. Meyers, a noted hustler, proved to be better at the tap than on the mound. (Charles Burkhardt.)

ROLLIE NAYLOR. Another forgettable face of the A's dismal seasons was Rollie Naylor, who lost 23 games for the A's in 1920. Fortunately for the White Elephants, his career was shortened by a leg injury in 1923. He went on to become a respected minor league umpire. (Charles Burkhardt.)

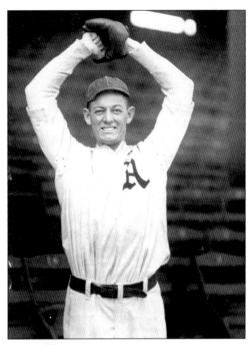

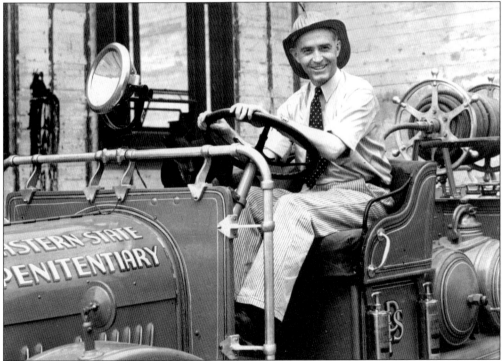

SHORTSTOP-TURNED-INMATE. Sam "Red" Crane was a light-hitting shortstop for the A's in 1915 and 1916. But he never attracted much attention until he was convicted of murdering a two-timing girlfriend. Sentenced to 18 to 36 years in Philadelphia's Eastern State Penitentiary, Crane joined the prison fire department and became the star player on Eastern State's baseball team. (Charles Burkhardt.)

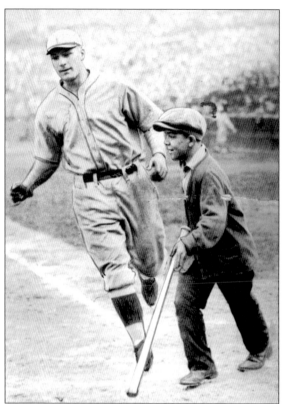

POWER-HITTING FIRST BASEMAN.
Left-handed power hitter Joe Hauser was one of Mack's more promising discoveries. Signed by Mack in 1922 from Milwaukee, the 22-year-old first baseman knocked out 9 home runs and 21 doubles in 111 games for a .323 average. He led the A's 2 years later with 27 home runs and 115 RBIs. It looked as though Mack had found a legitimate clean-up hitter until Hauser broke his kneecap in 1925 and missed the entire season. His attempt to win back the first-base job was foiled by another young power hitter by the name of Jimmie Foxx. Hauser returned to the minors where he earned the distinction of twice hitting 60 home runs in a season, with 63 for Baltimore of the International League in 1930 and 69 for Minneapolis of the American Association in 1933. (Charles Burkhardt.)

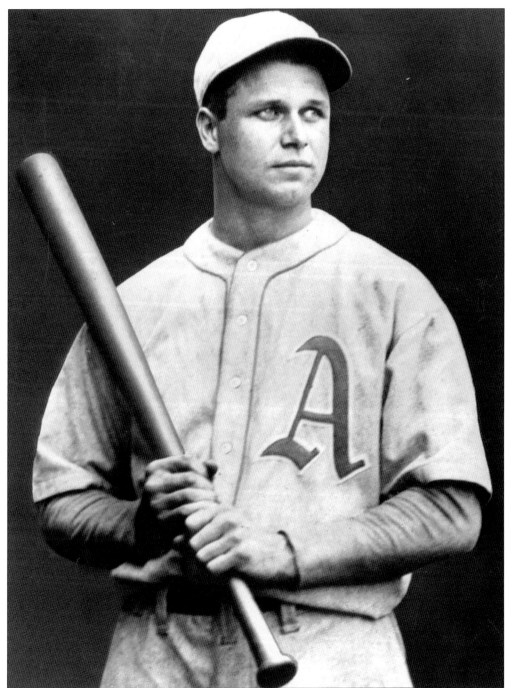

"DOUBLE X." Jimmie Foxx was a protégé of Frank "Home Run" Baker, who managed in the Eastern Shore (Maryland) League. After the Yankees refused to sign the 16-year-old slugger, Baker offered him to Connie Mack, in 1924, for $2,500. It was a bargain basement price for a player who would become one of the most feared sluggers in the American League. Originally a catcher, Foxx was converted to first base, where he proved to be the cornerstone of the A's second championship dynasty. (National Baseball Hall of Fame.)

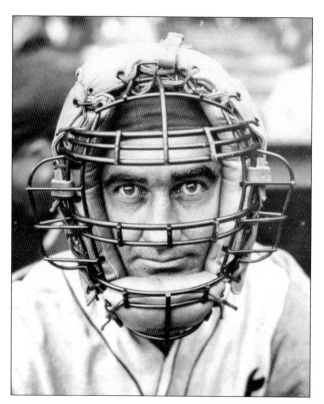

"BLACK MIKE." Mickey Cochrane was a Massachusetts farm boy who starred at halfback for Boston University. He went on to play for Portland of the Pacific Coast League, where he hit .338 and demonstrated exceptional speed on the base paths. Impressed by Cochrane's competitive spark, work ethic, and aggressive play, Mack purchased the entire Portland franchise for $50,000 just to secure his services. Cochrane's legendary temper tantrums earned him the nickname "Black Mike." (National Baseball Hall of Fame.)

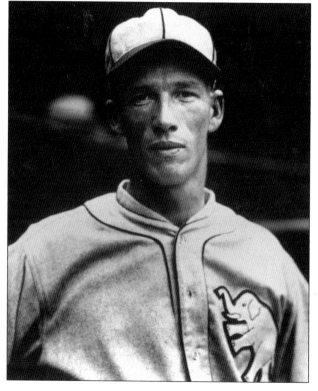

"LEFTY" GROVE. Mack's most famous deal came in 1925 when he purchased Robert "Lefty" Grove from the Baltimore Orioles of the International League for the unprecedented sum of $100,600, exceeding the $100,500 the Yankees paid for Babe Ruth five years earlier. Grove was already a legend in Baltimore where he had compiled a total of 109 victories and set International League records for innings pitched and strikeouts. (National Baseball Hall of Fame.)

MAX BISHOP. Mack also purchased second baseman Max Bishop from the Baltimore Orioles for $25,000 in 1924. A great two-strike hitter who was also talented at drawing walks, Bishop soon became the A's lead-off hitter. (Charles Burkhardt.)

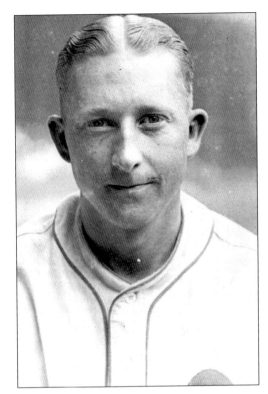

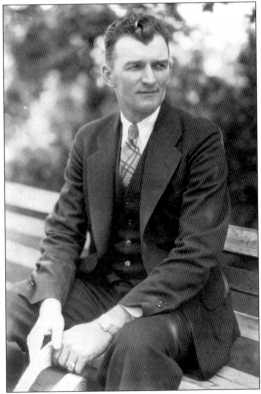

JOE BOLEY. Within three years time, Mack reunited Bishop with his keystone partner in Baltimore, Joe Boley. Purchased by the Tall Tactician for $60,000 in 1927, Boley was an exceptional fielder and steady hitter. The following season, the 28-year-old shortstop hit .311 for the A's. Mack had secured his middle infield. (Charles Burkhardt.)

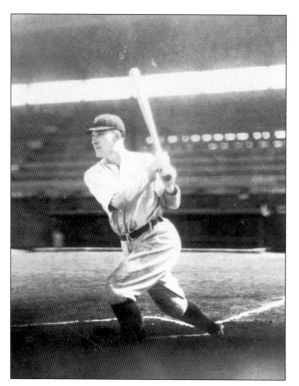

AL SIMMONS. The son of Polish immigrants in Milwaukee, Aloysius Szymanski modeled his American name after a hardware store ad, making it easier for the sportswriters to remember. Mack purchased his services from the Milwaukee Brewers in 1923 for $50,000. Other clubs had been unimpressed with Simmons, a right-handed hitter who pulled his left foot away from the pitcher and toward the dugout with every swing. The idiosyncrasy earned him the nickname "Bucketfoot Al." Despite his unorthodox style, Simmons "bucket-footed" his way to a .308 average in his rookie year, becoming a regular in the A's outfield. (Charles Burkhardt.)

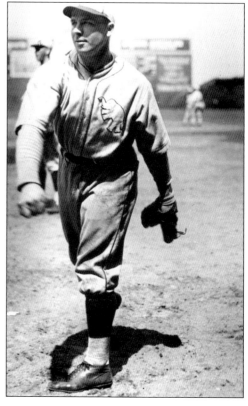

JIMMY DYKES. A Philadelphia native, Jimmy Dykes came to the A's in 1918. He was a temperamental fireplug who struck out four times in as many plate appearances in his first major league game. After taking him out, Mack, who always managed to find the humorous side of a dismal situation, explained his decision to the scrappy infielder. "You see, Jimmy," he said. "The American League record for striking out is five times in one game, and I didn't want you to tie it in your very first big league appearance!" (National Baseball Hall of Fame.)

COBB SIGNS WITH THE A'S. Determined to be the greatest ballplayer of his era, Ty Cobb refused to leave baseball when he was forcibly retired by the Detroit Tigers in 1926 for allegedly conspiring to fix a game earlier in his career. Cobb was proclaimed innocent, since there was no hard evidence, and allowed to sign with the Philadelphia A's. On February 9, 1927, Cobb was all smiles holding up his new jersey after signing for $70,000. (Philadelphia Athletics Historical Society.)

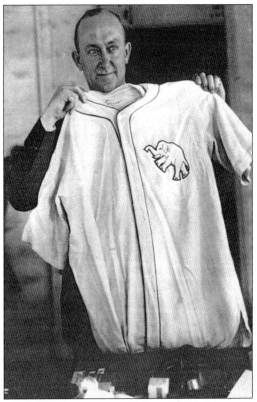

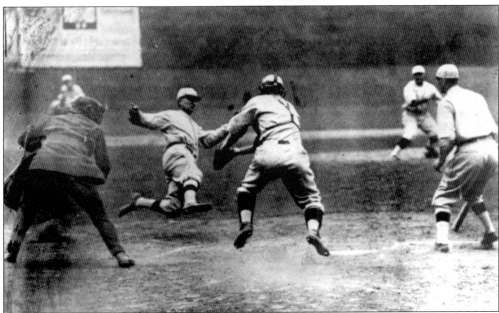

STEALING HOME. In 1927, Cobb vindicated himself by driving in or scoring 197 runs, stealing 22 bases, and hitting .357, fifth best in the American League. Here, he steals home in Boston on April 26, 1927, on pitcher Tony Welzer of the Red Sox. Umpire Billy Evans and batter Dudly Branom look on as Cobb eludes Grover Hartley's tag. (National Baseball Hall of Fame.)

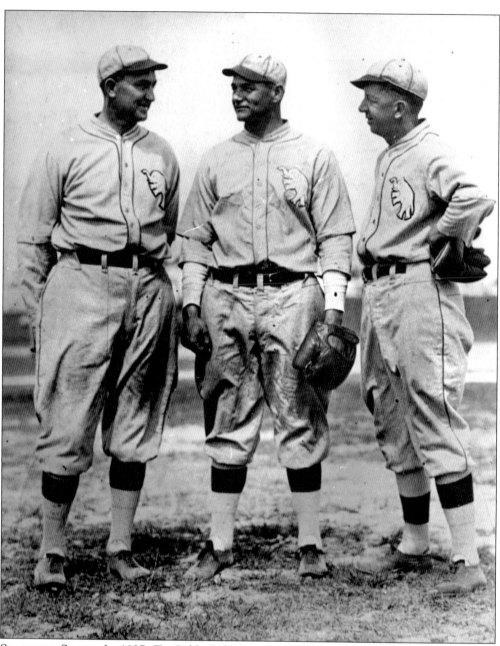

Seasoned Stars. In 1927, Ty Cobb (left) was joined by two other future Hall-of-Famers: outfielder Zack Wheat, who starred for the Brooklyn Dodgers; and player-coach Eddie Collins, who returned to Philadelphia after 12 years with the Chicago White Sox. Mack hoped the trio of veteran stars would provide the kind of baseball knowledge and experience that would benefit his budding young stars, which included four other future Hall-of-Famers: Al Simmons, Jimmie Foxx, Lefty Grove, and Mickey Cochrane. (National Baseball Hall of Fame.)

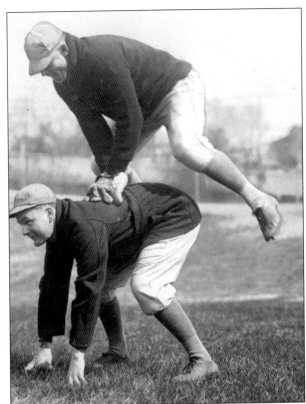

SPRING TRAINING. Win or lose, the A's always managed to have fun during spring training, as evidenced by leap froggers Bing Miller and Fred Heimach, and coach Eddie Collins dragging protégé Jimmy Dykes off the beach. (Charles Burkhardt.)

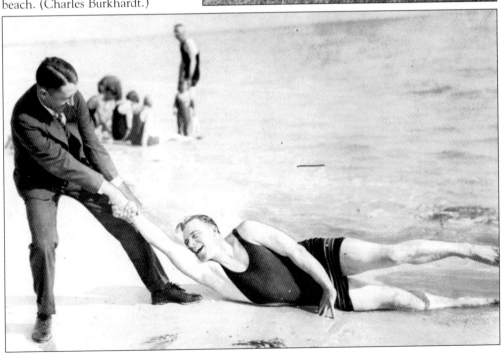

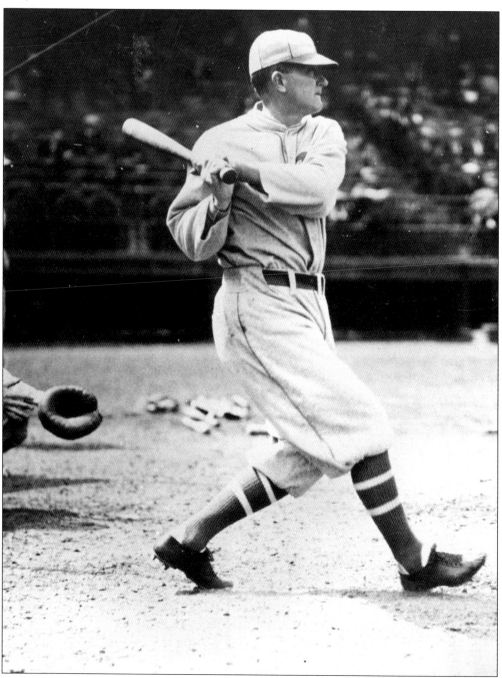

COBB'S LAST STAND. Though his mind and batting eye were sharp as ever, Cobb's legs betrayed him in 1928. At age 43, he was always a step behind, unable to take the extra base, steal third, or catch a rapidly sinking line drive. He made his final appearance in the last game of a climactic four-game series against the New York Yankees on September 11th. Coming off the bench to pinch hit in the ninth inning of a 3-3 tie, Cobb lined out to Yankee shortstop Mark Koenig and then trotted into the history books. His lifetime batting average of .367 is still the highest ever compiled in major league baseball. (National Baseball Hall of Fame.)

Four

DAMN THE YANKEES: 1929–1931

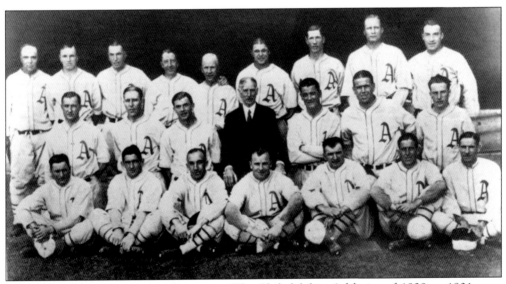

THE SECOND CHAMPIONSHIP DYNASTY. The Philadelphia Athletics of 1929 to 1931 were among the greatest teams of all time. Over the course of those three years, they won two world championships and three American League pennants for a total record of 313 victories. While the 1927 New York Yankees are considered by many the best team of all time, the A's teams of this era had better pitching, defense, and utility players. The 1929 team, pictured here, captured the pennant by out-distancing the Yankees by 18 games. New York would finish 16 games out in 1930 and 13.5 games out in 1931 as the A's continued to dominate the baseball world. (National Baseball Hall of Fame.)

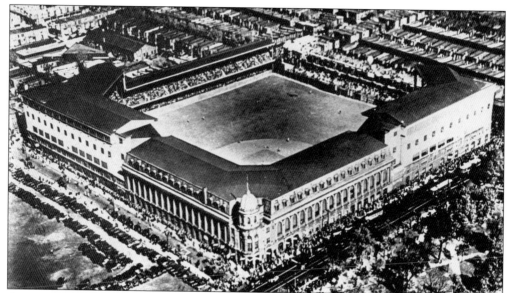

AERIAL AND INTERIOR VIEWS OF SHIBE PARK, 1929. The Roaring Twenties brought a new popularity to baseball. Twenty-first Street and Lehigh Avenue became the focal point for Philadelphia's ethnically diverse population. On game day, the blocks surrounding Shibe Park became the scene of controlled pandemonium. Clanging bells of the street trolleys, ooo-gahs of car horns, and piercing shrills of the cops' traffic whistles cut the air. People scurried to buy tickets—50¢ for bleachers, $1.25 for grandstand seats, and $2 for box seats— and poured through the turnstiles. Inside, vendors made their pitch: "Getchur scorecard lineup!" "Peanuts!" "Ice cream!" At 3:15 p.m., the national anthem was played. Shortly after, the ballpark announcer called out the starting line-ups through his megaphone and the home plate umpire cried, "Play ball!"(Top: Temple University Urban Archives, Bottom: Charles Burkhardt.)

CONNIE MACK, 1929. At the seasoned age of 66, Mack's managerial skills were being called into question by many a sportswriter. After all, the A's had not won a pennant since 1914, and many Philadelphians suspected that the A's skipper had lost his ability to judge talent and to create a team of winners. Besides, his last World Series came during the Dead Ball Era when the strategy of the game emphasized pitching and manufacturing runs by executing the bunt, stolen base, and sacrifice fly. Could Mack succeed in the age of the "lively ball" where the home run captured the imagination of the fans and power hitters reigned? A second championship dynasty that began in 1929 vindicated Mack. (Charles Conlon Collection of the National Baseball Hall of Fame.)

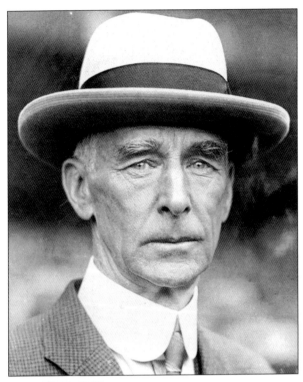

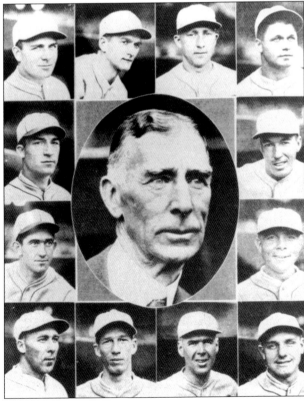

MACKMEN, 1929–1931. Baseball became a symbolic representation of the American Dream for Philadelphia's immigrant population. The ability to compete on even terms with an opponent— to step up to the plate and seize the chance for glory no matter what your ethnic background—was so cherished by these new arrivals that they encouraged their sons to play the game. The A's were an especially attractive team because each one of Philadelphia's immigrant groups could root for "one of their own kind." Al Simmons and Joe Boley were of Polish extraction. The German fans cheered-on pitcher Eddie Rommel, the English blue bloods found a hero in George Earnshaw (a graduate of Swarthmore College), and the Irish fans had Jimmy Dykes, Mickey Cochrane, and Connie Mack himself. (National Baseball Hall of Fame.)

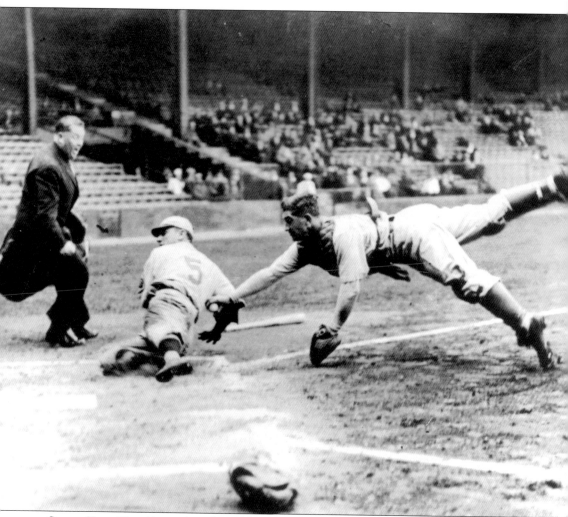

SWEEP TAG. The A's rough-and-tumble style of play endeared them to the fans. Much like the Roaring Twenties, the players were sharp-witted and strong, reckless and carefree, brutally candid and shamelessly self-indulgent. Cochrane, the A's catcher and team captain, epitomized the team. His daring performance on the playing field, shown here, earned the respect of opponents and teammates alike. (National Baseball Hall of Fame.)

"LEFTY" GROVE. Robert "Lefty" Grove was the pitching ace of the second championship dynasty. In 1929, he posted a 20-6 record, 170 strikeouts, and a 2.81 ERA. He won another 28 in 1930 and had his best season ever in 1931, posting a 31-4 record and a 2.06 ERA. Widely considered the greatest left-hander of the era, Grove's exploding fast ball was exceeded only by his violent temper. (National Baseball Hall of Fame.)

MICKEY COCHRANE. Even more competitive was catcher Mickey Cochrane. Known as "Black Mike" to a legion of admirers, Cochrane's exuberant spirit—as well as his .346 batting average—sparked the A's to three straight pennants. (National Baseball Hall of Fame.)

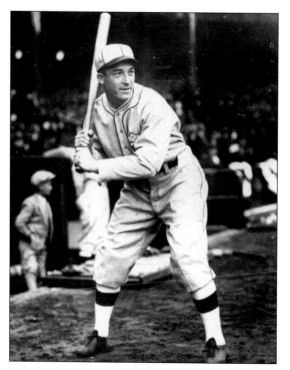

AL SIMMONS. Outfielder Al Simmons could be downright vicious at the plate, working himself into a rage against pitchers whom he considered "mortal enemies." His unorthodox batting style earned him the nickname "Bucketfoot Al." In 1929, Simmons knocked in 157 runs to take the American League crown in RBIs. In the next two years, he captured the League's batting title with a .381 average in 1930 and a .390 mark in 1931. (National Baseball Hall of Fame.)

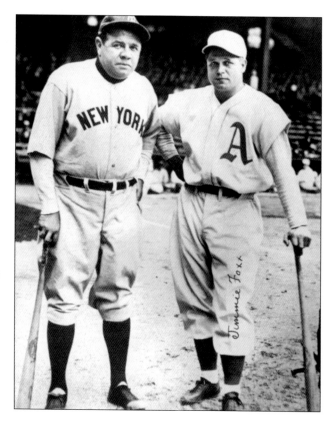

JIMMIE FOXX WITH THE BABE. Jimmie Foxx, also known as "Double X," launched home runs even farther than Babe Ruth himself. Beginning in 1929, Foxx hit 30 or more round trippers for 12 straight seasons and, in 1932, just missed tying Ruth's season record of 60 when a rainout erased two of the homers he had hit. (National Baseball Hall of Fame.)

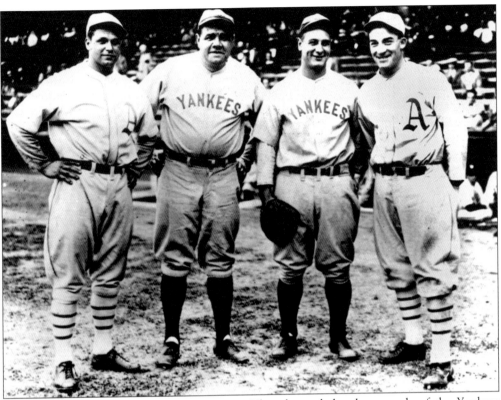

TOP SLUGGERS OF THE 1920S AND 1930S. Though much has been made of the Yankees power-hitting tandem of Babe Ruth and Lou Gehrig (pictured at center), Jimmie Foxx (extreme left) and Al Simmons (extreme right) presented formidable competition to the Bronx Bombers. Between 1927 and 1933, these four sluggers set the standard for power-hitting in baseball. (National Baseball Hall of Fame.)

GEORGE EARNSHAW. The A's 1929 pitching staff was solid. Lefty Grove was complemented by George Earnshaw, shown here, who posted a 24-8 record and a 3.28 ERA. (Charles Burkhardt.)

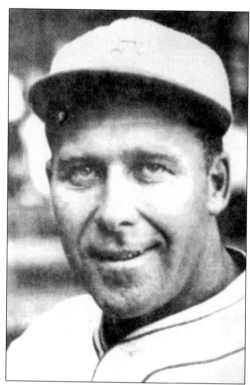

THE A'S PITCHERS. Strong pitching skills did not stop with George Earnshaw. Rube Walberg (above) went 18-11 and surrendered only 3.59 runs per game in his career. Closer Ed Rommel (below) went 12-2 with an impressively low ERA of 2.84. (National Baseball Hall of Fame.)

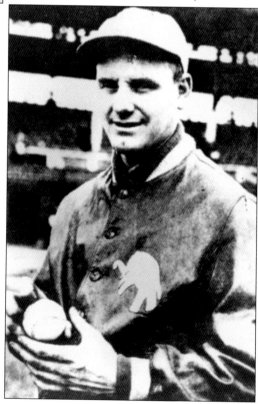

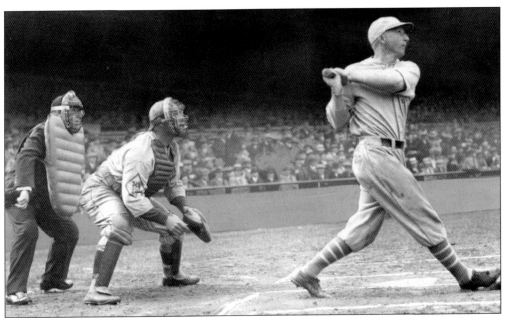

MAX BISHOP AT BAT. Second baseman Max Bishop, who was the A's lead-off man, hit only .232 in 1929, but he walked almost once a game for a total of 128 free passes that season. (Charles Burkhardt.)

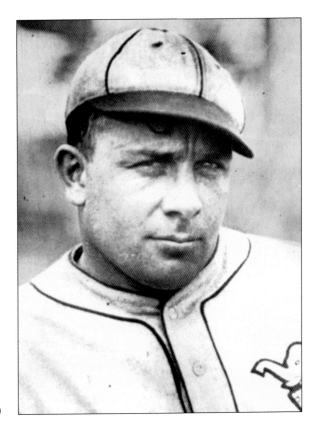

JIMMY DYKES. Nothing seemed to get past third baseman Jimmy Dykes or his protruding tailgate in 1929. He was just as deadly at the plate, compiling a .327 average, 79 RBIs, and 13 homers. (Charles Burkhardt.)

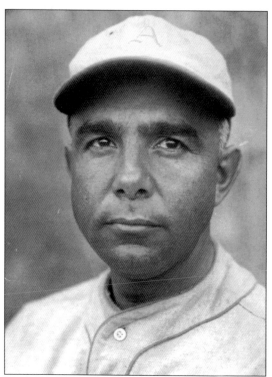

BING MILLER. A dependable, hard-hitting outfielder, Bing Miller was dealt to the St. Louis Browns by Connie Mack in 1926 but was reacquired the following season. In 1929, he batted .335 and collected 93 RBIs. (Charles Burkhardt.)

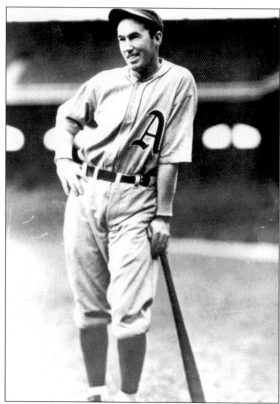

GEORGE "MULE" HAAS. Adopting the playing style of his tutor, Tris Speaker, George Haas played a shallow outfield and loped back to catch fly balls over his shoulder. One of the A's masterful bench jockeys, Haas hit .313 with 16 homers and 82 RBIs in 1929. (National Baseball Hall of Fame.)

54

HOWARD EHMKE. Mack surprised everyone by passing up Lefty Grove and starting 35-year-old Howard Ehmke, who appeared in only 11 games all season, as his opening pitcher in the 1929 World Series against the Chicago Cubs. Ehmke's underhanded, submarine-style delivery baffled the Cub hitters. He fanned 13, setting a new World Series record, and won the opener, 3-1, at Chicago's Wrigley Field. (National Baseball Hall of Fame.)

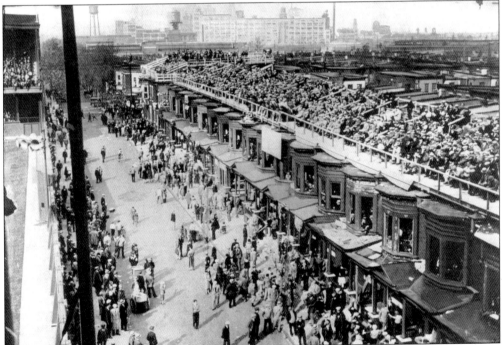

ROOFTOP SQUATTERS. During the 1929 World Series, the row-house residents of North Twentieth Street, which bordered Shibe Park's right field fence, constructed portable bleachers on their rooftops, removed the windows from their front bedrooms, and sold tickets to watch the games to those not fortunate enough to get seats inside the park. (Temple University Urban Archives.)

55

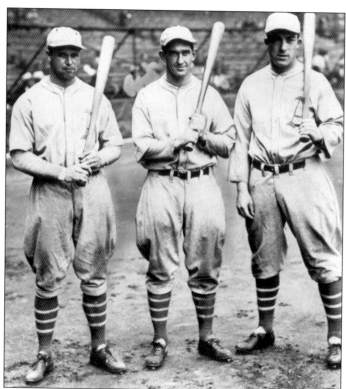

PHILADELPHIA'S MURDERER'S ROW. The Cubs appeared to be on the verge of evening the World Series with an 8-0 lead in the seventh inning of game four. But the bats of Foxx, Cochrane, and Simmons came alive to lead an incredible 10-run rally, and the A's went on to win the game, 10-8. It was the greatest rally in World Series history, establishing new series records for runs scored in a single inning (10), hits in one inning (10), and at bats (15). (National Baseball Hall of Fame.)

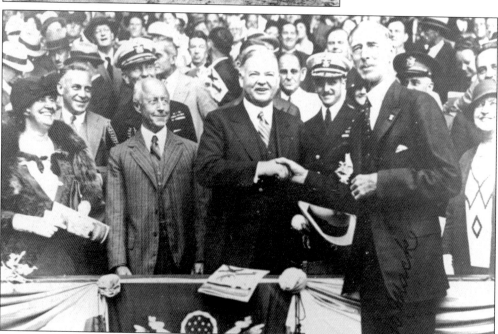

GREETING PRESIDENT HOOVER. Connie Mack greeted President Herbert Hoover before game five of the 1929 World Series at Shibe Park. The A's fans were less welcoming, registering their disapproval of Prohibition with the following chant: "Beer! Beer! We want beer!" (National Baseball Hall of Fame.)

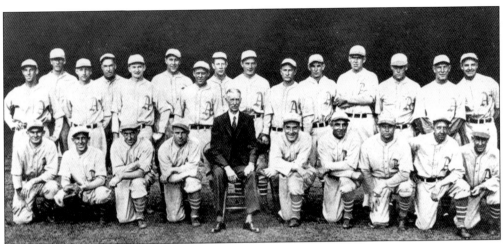

THE 1930 A's TEAM. Philadelphia's celebration of the World Champion Athletics in 1929 was short-lived. Just two weeks after the A's clinched the World Series, the stock market crashed, ending the golden era of prosperity. Soon the nation slid into a major economic depression. But the A's managed to lessen the pain of Philadelphia's baseball fans by capturing a second straight pennant in 1930. (National Baseball Hall of Fame.)

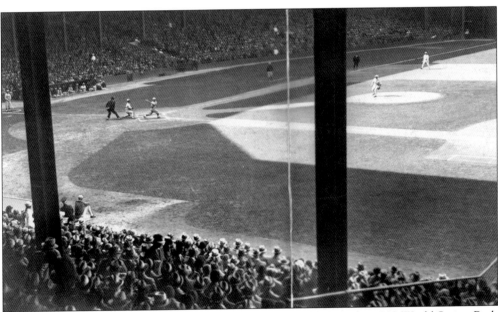

THE 1930 WORLD SERIES. The A's met the St. Louis Cardinals in the 1930 World Series. Both teams suffered through offensive slumps, the A's hitting an anemic .197 and the Cardinals not much better at .200. The difference proved to be the pitching of George Earnshaw, who compiled a 2-0 record and a 0.72 ERA in the 25 innings he pitched, and Lefty Grove, who posted a 2-1 record and a 1.42 ERA in the 19 innings he pitched. The A's clinched the series in six games. It was the last world championship that Connie Mack would ever claim. (Charles Burkhardt.)

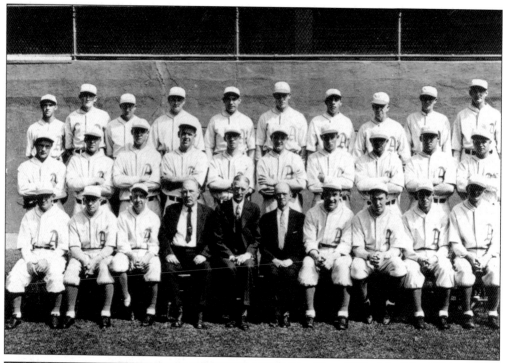

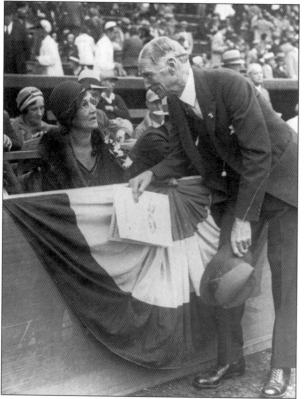

THE 1931 A's. The 1931 season was a cakewalk for Mack and the A's. Not only did they finish 13.5 games ahead of the New York Yankees, but also they won more than 100 games for the third consecutive year. Lefty Grove was the star performer, compiling one of the greatest individual records in baseball history. He posted a 31-4 record for an extraordinary .886 winning percentage, 175 strikeouts, and an impressively low 2.05 ERA. The A's were odds-on favorites to sweep the St. Louis Cardinals in the World Series. Instead, the Mackmen fell to the Cards in seven games, ending Mack's second and final championship dynasty. (National Baseball Hall of Fame.)

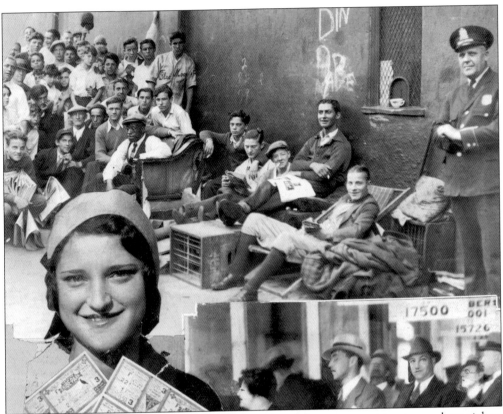

FANS WAIT FOR SERIES TICKETS. A's supporters lined the streets waiting to purchase tickets to the 1931 World Series. At least one attractive fan got her share of passes, only to be disappointed when her team fell to the Cardinals in seven games. (Charles Burkhardt.)

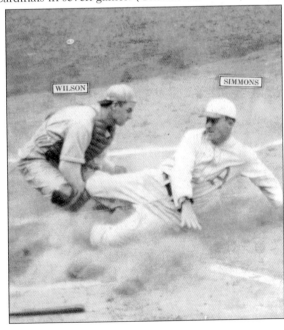

SIMMONS SLIDES HOME. Al Simmons slides home safely with the A's second run in game seven of the 1931 World Series. It would not be enough, as the Cardinals clinched the series with a 4-2 win. (Charles Burkhardt.)

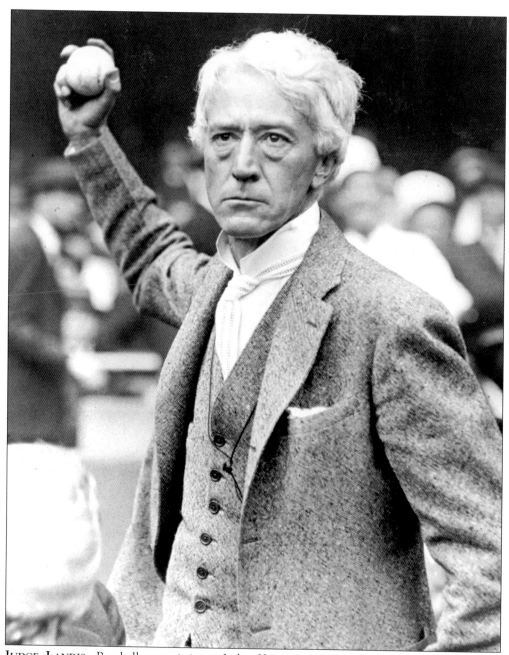

JUDGE LANDIS. Baseball commissioner Judge Kenesaw Mountain Landis was not entirely displeased to see the passing of the A's dynasty. Appalled at the profane bench jockeying of Mickey Cochrane, Al Simmons, and Jimmy Dykes, Landis reprimanded them publicly during the 1929 World Series. (National Baseball Hall of Fame.)

Five

MACK THE KNIFE: 1932–1937

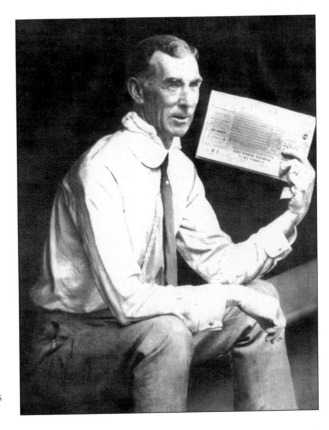

MACK FEELS THE HEAT. In 1932, Connie Mack, who claimed that he could tell when a great team was done for, decided to break up his second championship dynasty. Undoubtedly, he was also influenced by the nation's economic plight. With the Great Depression growing worse, Mack, who owned 50 percent of the team by now, could not afford to pay his star players. The A's were carrying the largest payroll in baseball and, despite the success of the team, attendance was actually down. Banks began to call in earlier loans they had made to the A's to expand the seating at Shibe Park. With little financial relief in sight Mack, once again, began to sell off his team. Simmons, Dykes, and Haas were the first to go, being sold to the Chicago White Sox for $100,000. (Philadelphia Athletics Historical Society.)

COCHRANE'S LAST YEAR. Nineteen thirty-two would be Mickey Cochrane's last year as the A's catcher. Shown here, on the right, enjoying the rituals of spring training, his attitude and batting average went into a slump. That season Cochrane's hitting dropped from .349 to .293. In December, he was sold for $100,000, along with a young backstop, John Pasek, to the Detroit Tigers. (Charles Burkhardt.)

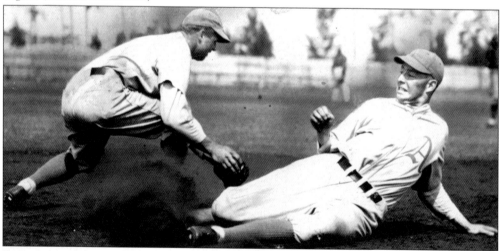

DOC CRAMER. Replacing departed outfielder Mule Haas in the lineup was Roger Cramer. Cramer, shown sliding back to first base, was a swift, agile fly-catcher. Sportswriter Jimmy Isaminger nicknamed him "Flit," after the insecticide, because he was death to fly balls. He was also a regular .300 hitter for the A's until Mack dealt him away in 1936 to the Boston Red Sox. (Charles Burkhardt.)

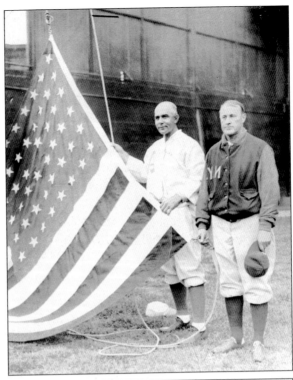

ANOTHER PLAYER TURNED COACH. Along with Eddie Rommel, Mack recruited former player Bing Miller to coach. Here, he raises the flag during opening day ceremonies at Shibe Park in 1934. Standing alongside is Yankee coach Art Fletcher. (Charles Burkhardt.)

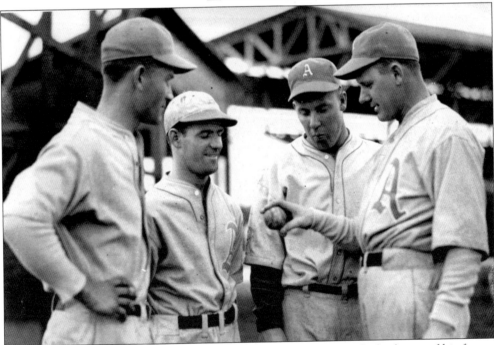

A BLAST FROM THE PAST. Just as he had done before, Mack brought back two of his former players as coaches to cultivate what he hoped would become a third dynasty. Here, pitching coach Eddie Rommel gives instructions to a group of young hurlers including, from left to right, Harry Matuzak, Belmont Denau, and Johnny Marcum. (Charles Burkhardt.)

HERO WORSHIP. Between 1932 and 1935 when he was traded to the Red Sox, Jimmie Foxx was the cornerstone of the A's. In 1933, he won the triple crown with a .364 batting average, 58 home runs, and 169 RBIs. He was also a hero to youngsters, giving them his undivided attention. Realizing the financial strain on Mack, Foxx took a $366 cut in pay to remain with the team in 1933. (The *Baltimore Sun*.)

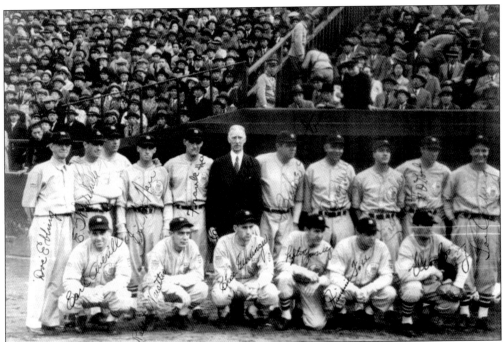

THE 1934 JAPANESE TOUR. After the 1934 season, Mack accompanied a team of American League All-stars to the Orient to promote the game. Babe Ruth actually managed the team, while Mack served more as an ambassador. At age 75, Mack was also curious to see if Ruth, for whom he had a special fondness, could replace him as the A's manager. That, of course, never happened. (Philadelphia Athletics Historical Society.)

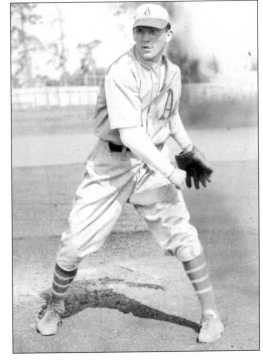

"BULLFROG BILL" DIETRICH. Mack realized that Philadelphians embraced home-town talent. To accommodate them, he signed pitcher Bill Dietrich of Frankford in 1933. Unable to see without his glasses, Dietrich was among the league leaders with 100 or more walks in 1934 and 1935. Mack gave up on him in 1936, waiving him to Washington. (Charles Burkhardt.)

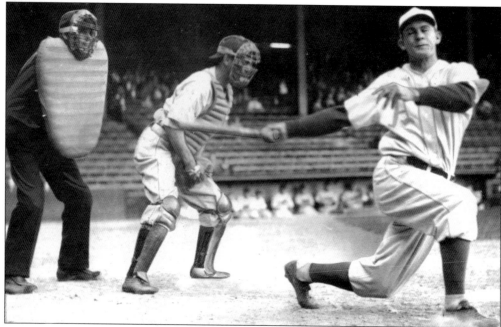

MIKE "PINKY" HIGGINS TAKES A CUT. Not all of Mack's prospects were a bust during these years. Pinky Higgins, signed out of the University of Texas, proved to be a hard-hitting third baseman who was especially dangerous with runners in scoring position. Of course, Higgins enjoyed the most successful part of his career after he left Philadelphia in 1936. (Charles Burkhardt.)

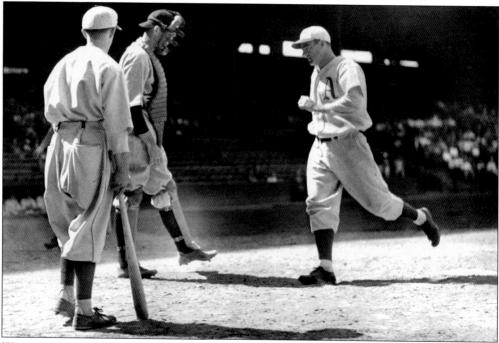

WALLY MOSES. Another great find was outfielder Wally Moses, who debuted with the A's in 1935. He hit .300 or better each of the seven seasons he played in Philadelphia. Moses's best season came in 1937 when he hit .320 and collected 25 homers and 86 RBIs. (Charles Burkhardt.)

LOU FINNEY. Mack hoped that outfielder Lou Finney would replace Al Simmons's offensive production during the 1930s. While that did not happen, Finney did prove to be a steady hitter and something of a clown in spring training. Here he is with a Mexican sombrero, lugging the water supplies. (Charles Burkhardt.)

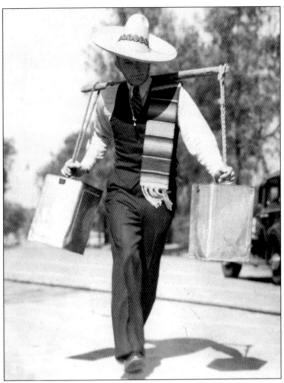

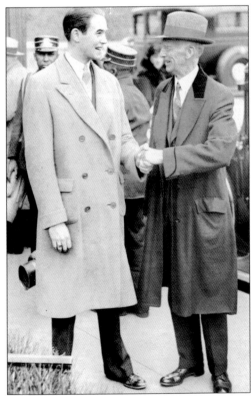

FATHER AND SON. Connie Mack Jr. greets his father on his return to Philadelphia from spring training in 1934. The younger Mack was a standout prep school athlete at Germantown Academy. (Charles Burkhardt.)

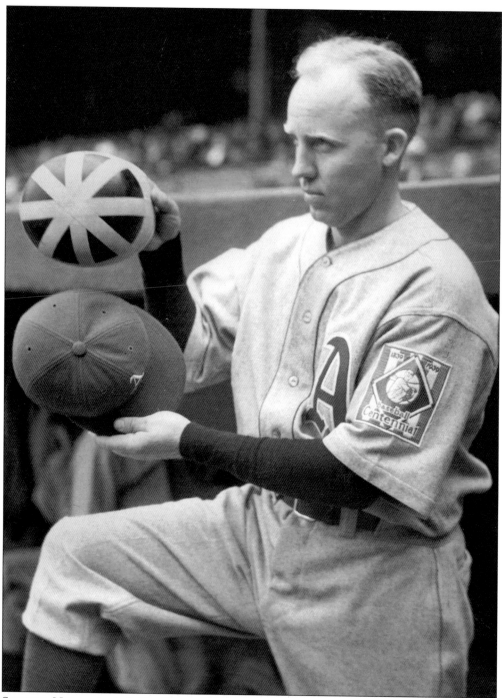

SKEETER NEWSOME. Infielder Lamar "Skeeter" Newsome was a pesky hitter with speed. He provided Mack with reliable service at second, short, and third, and some offensive spark coming off the bench. (Charles Burkhardt.)

SPRING TRAINING. Despite their perennial residence in the second division during these years, the A's always found time to have fun at their Fort Myers, Florida, spring training facility, both on and off the field. Pepper games (above) were a daily routine. Singing along with piano-playing pitcher Bill Dietrich filled the evenings (below), along with card games, shooting pool, and swapping yarns. (Charles Burkhardt.)

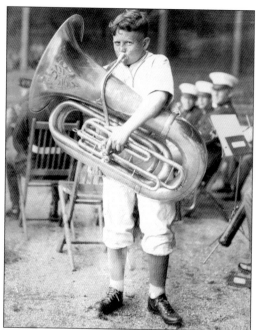

THE A'S MASCOT. Jimmy Webb, the A's mascot, provided some color to the 1935 opening day ceremonies by blowing a tuba. Unfortunately the A's blew the game, 6-4, to Washington. (Charles Burkhardt.)

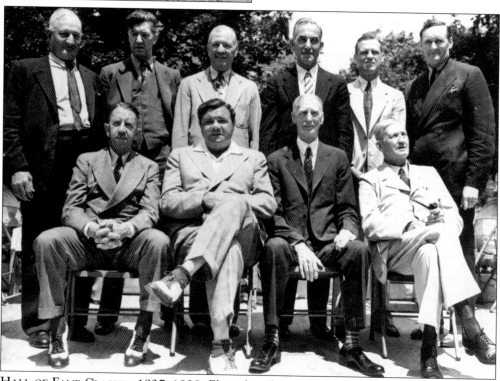

HALL OF FAME CLASSES, 1937–1939. Elected to the Baseball Hall of Fame in 1937, Connie Mack joined other baseball immortals at the 1939 induction ceremonies. From left to right are the following: (front row) Eddie Collins, Babe Ruth, Connie Mack, and Cy Young; (back row) Honus Wagner, Grover Alexander, Tris Speaker, Nap Lajoie, George Sisler, and Walter Johnson. (National Baseball Hall of Fame.)

Six

A GENTLE COMEDY:
1938–1947

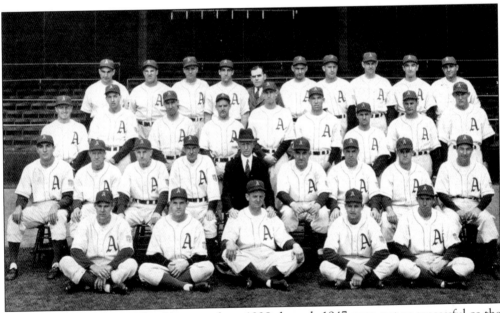

THE 1942 ATHLETICS. The A's teams from 1938 through 1947 were not as successful as the earlier, championship dynasties, finishing in the cellar for all but three seasons. But they were still exciting to watch. Described as a "gentle comedy" by the novelist John Updike, many of those A's teams featured outfielders who ran into walls—or each other—in pursuit of a fly ball and quality players who were traded away for unknowns. The 1942 A's squad, pictured here, reflected the dismal teams of this decade. The team finished in last place, 48 games behind the American League champion Yankees. (Philadelphia Athletics Historical Society.)

INDIAN BOB JOHNSON. Replacing Al Simmons in the A's outfield in 1933, Bob Johnson had speed, power, and consistency at the plate. For seven straight seasons, he drove in over 100 runs and batted .290 or better with a peak average of .338 in 1939. Known as "Indian Bob" because of his Cherokee background, Johnson was one of the few players who had difficulty with Connie Mack. Johnson believed that he was underpaid and demanded a trade. Mack complied in 1943, sending him to the Washington Senators. (Philadelphia Athletics Historical Society.)

EDDIE COLLINS JR. Son of the A's legendary second baseman, Eddie Collins, Eddie Jr. debuted with the Mackmen in 1939, the same year his father was inducted into the Hall of Fame. The young outfielder spent only three seasons with the A's as a utility outfielder and pinch hitter. His best season in Philadelphia came in 1941 when he appeared in 50 games and hit .242. (Philadelphia Athletics Historical Society.)

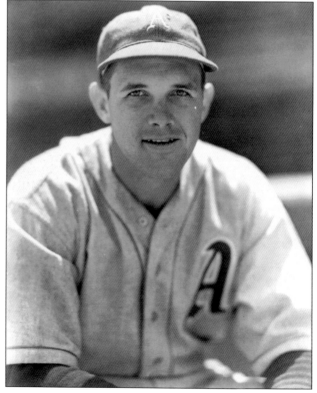

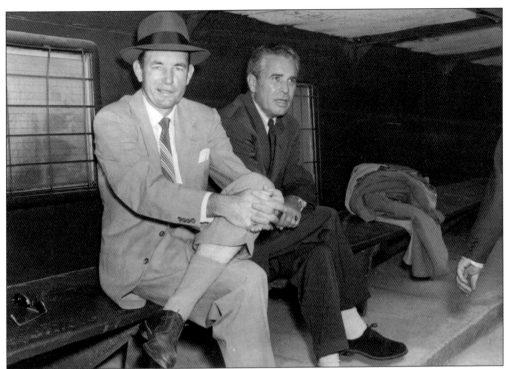

THE VOICE OF THE ATHLETICS. Between 1938 and 1954, By Saam did the play-by-play over the radio for the Athletics. His smooth and mellow voice gave some hope to A's fans as they suffered through the trying times. When the A's inevitably fell 40 games below .500, Saam still managed to provide reassurance by talking about the team's "great prospects for next year." Among his associates during his 17 years as the A's radio broadcaster was Taylor Grant, pictured on the right. Saam completed his radio career in the late 1970s with the Philadelphia Phillies and was inducted into the Hall of Fame in 1990. (Philadelphia Athletics Historical Society.)

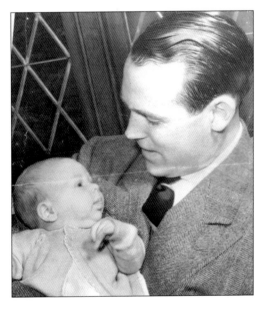

TWO MORE CONNIE MACKS. Connie Mack IV, held by his father Connie Jr., was born on October 29, 1940. Since the father's older stepbrother, Roy, named his son Connie III, Connie Jr.'s two-month-old son became the fourth. (Charles Burkhardt.)

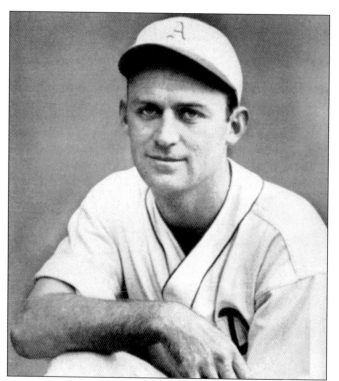

SAM CHAPMAN. An All-American football player at the University of California, Sam Chapman gave up the gridiron to sign with the A's in 1938. With exceptional speed, power, and a strong arm, Chapman appeared to be poised to lead the A's back into contention. In 1941, he hit .322 with 25 home runs and 106 RBIs. It would be his most productive season in the majors. With the outbreak of World War II, Chapman enlisted in the U.S. Navy. After he returned to the majors at the end of the 1945 season, he never hit .300 again. (Philadelphia Athletics Historical Society.)

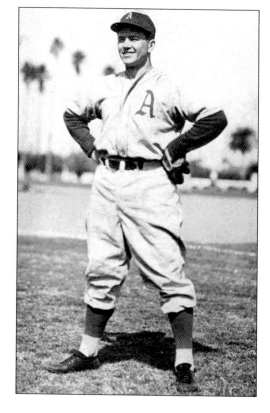

ELMER VALO. Born in Ribnik, Czechoslovakia, Elmer Valo signed with the A's in 1940 and became a regular in the outfield two years later. The 5-foot 10-inch contact hitter was known for his fearless style of play. Banging himself off outfield walls, he robbed power hitters with his reckless pursuit of near home runs. During his 13 years with the A's (1940–1943; 1946–1954), Valo hit .300 or better six times. (Philadelphia Athletics Historical Society.)

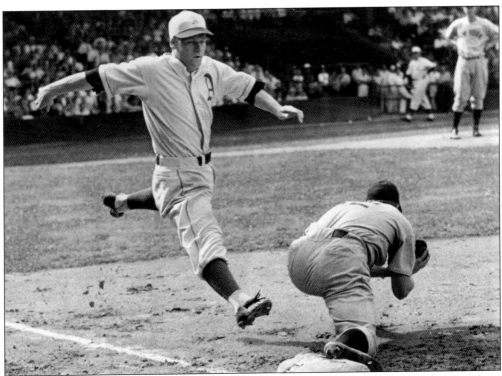

$45,000 BONUS BABY. Ten teams bid for Benny McCoy, a hot infield prospect who, along with 91 other Detroit minor leaguers, had been set free by Commissioner Landis in 1939. Mack paid McCoy $45,000 to sign with the A's and gave him a two-year contract at $10,000 a season. Although he was popular with the ladies, McCoy proved to be a disappointment. He played second base for the A's for just two seasons, hitting .260 over that two-year span. McCoy spent the next four years in the U.S. Navy, never returning to the major leagues. (Charles Burkhart.)

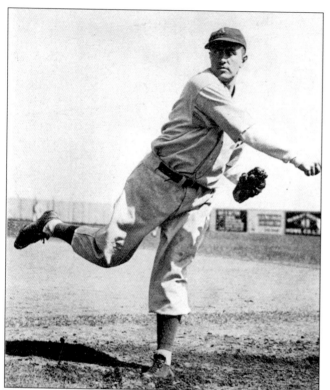

NELS POTTER. The only major league pitcher ever suspended for throwing a spitball, Nelson Potter came to the A's from the St. Louis Cardinals in 1938. Over the next three seasons, he compiled a poor 19-38 mark, and in 1941 he was sold to the Boston Red Sox. After a successful stint with the St. Louis Browns, where he went 19-7 and helped the team to a pennant, Potter returned to the A's as a reliever. A favorite of the younger fans, the right-handed hurler got into an argument with Connie Mack in 1948 and was summarily fired by Mack. Potter signed with the Braves, helping them to win the National League pennant with a 5-2 record. (Top: Philadelphia Athletics Historical Society; Bottom: Charles Burkhardt.)

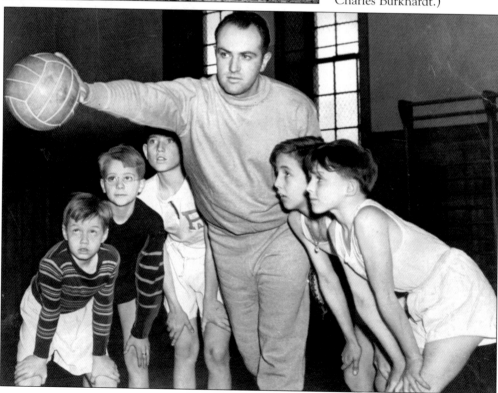

A's Enlist. After the bombing of Pearl Harbor on December 7, 1941, some of the A's enlisted in the military and others were drafted. Sam Chapman (pictured at left) and the Cleveland Indians' Bob Feller were two who enlisted. (Philadelphia Athletics Historical Society.)

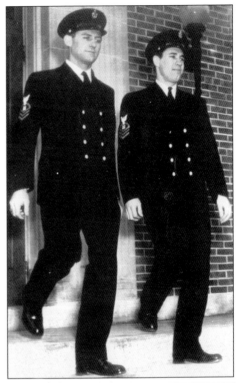

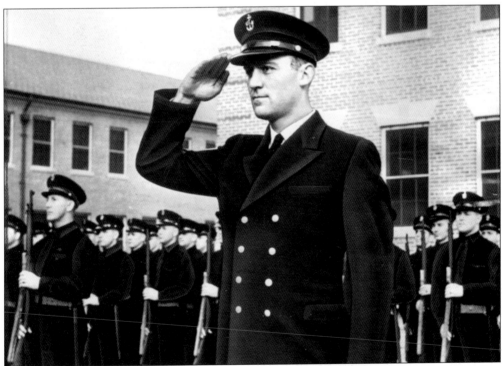

You're in the Navy Now! Sam Chapman salutes at the head of a platoon of chief specialists at the Norfolk, Virginia, Naval Training Station. (Charles Burkhardt.)

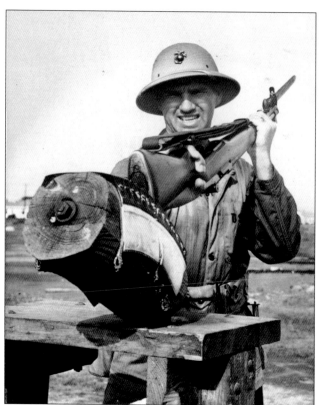

AMONG THE "FEW GOOD MEN." Marine Private and former A's pitcher Bert Kuczynski practices the "vertical butt stroke" on the bayonet course at Parris Island, South Carolina, where he was in boot camp in August 1943. (Charles Burkhardt.)

LT. JAMES CASTIGLIA. Castiglia, an A's catcher and former football player with the Philadelphia Eagles, became a physical instructor for the Army Air Forces Technical Training Command in 1943. (Charles Burkhardt.)

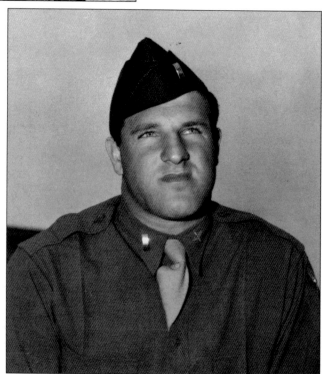

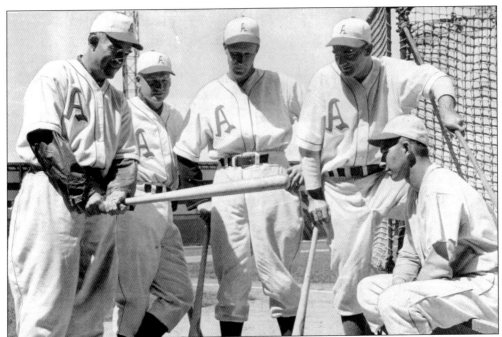

SIMMONS AND BENDER RETURN. Mack continued to employ his former players as coaches during the late 1930s and 1940s. Above, Al Simmons gives some pointers on hitting to Benny McCoy, Dee Miles, Wally Moses, and Hal Wagner. Below, Mack discussing hitting fundamentals with Chief Bender. (Top: Rich Westcott; Bottom: Philadelphia Athletics Historical Society.)

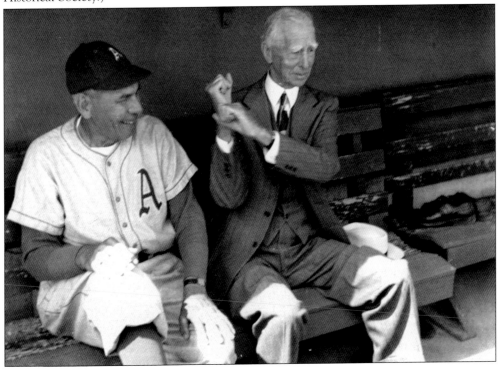

"CRASH" DAVIS. Lawrence Davis was a light-hitting second baseman for the A's from 1940 to 1942. Nicknamed "Crash" because of a collision he suffered going for a pop-up, Davis later became a legend in the Carolina League playing for the Durham Bulls, Raleigh Capitals, and Reidsville Luckies from 1948 to 1952. National fame came in 1988 when actor Kevin Costner used his name to portray a minor league lifer in the movie *Bull Durham.* (Philadelphia Athletics Historical Society.)

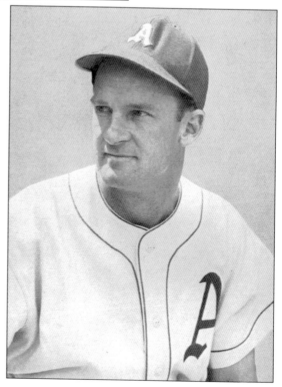

GEORGE MCQUINN. Obtained by the A's in 1945 from the St. Louis Browns, George McQuinn was asked to fill the void at first base left by Dick Siebert. McQuinn had been a St. Louis regular for eight years, leading American League first basemen in fielding three times and assists twice. But in 1946, his one and only season in Philadelphia, the ex-Brownie batted only .225 and committed 15 errors, the highest for American League first basemen. McQuinn left the A's for the New York Yankees, where he became an All-star for the next two years. (Philadelphia Athletics Historical Society.)

"BUDDY" ROSAR. Warren Vincent Rosar was the Yankees back-up to catcher Bill Dickey for four years. Traded to Cleveland after the 1942 campaign, he became an All-star. Rosar came to the A's in 1945. Though he batted an anemic .210, he became the A's regular catcher. The following season, Rosar set the record for errorless games by a catcher, fielding 1.000 in 117 games, a streak he extended to 147 games the following year. His defensive excellence earned him All-star appearances in 1946, 1947, and 1948 before being traded to the Red Sox after the 1949 season. (Philadelphia Athletics Historical Society.)

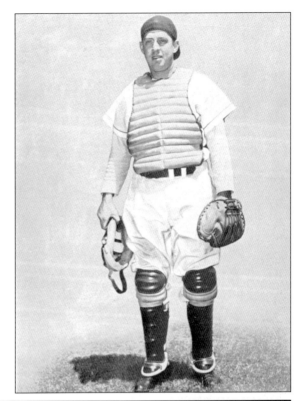

1943 ALL-STAR GAME. On July 13, 1943, the All-star game was played at Philadelphia's Shibe Park. A crowd of 31,938 came to see the very first mid-summer classic played at night time. The American League won, 5-3. (Charles Burkhardt.)

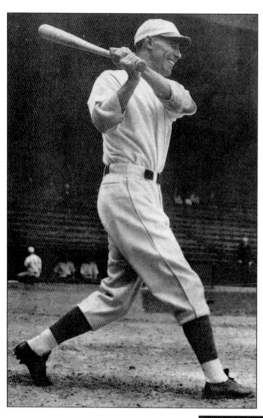

DICK SIEBERT. A flashy fielder and line drive hitter, Dick Siebert was the only A's representative at the 1943 All-star game. Siebert played for the A's between 1938 and 1945. He was especially good at scooping low throws out of the dirt and led the American League in assists in 1945. After the 1945 season, Siebert was traded to the Browns. When they tried to cut his salary, he retired. Siebert became a baseball coach at the University of Minnesota where he won the College World Series in 1956 and 1960 through 1964. (Philadelphia Athletics Historical Society.)

FUTURE HALL-OF-FAMER. Third baseman George Kell was the best ballplayer to emerge during the World War II player shortage. Beginning his major league career in 1943 with the A's, Kell was traded to Detroit for Barney McCosky on May 18, 1946. When he called the young infielder at his hotel room to inform him of the trade, Mack said, "You're going to be a great one, but I'm trading you because I can't afford to pay your salary." Mack was correct. Kell went on to become a perennial All-star and eventually earned a bronze plaque at Cooperstown. (Philadelphia Athletics Historical Society.)

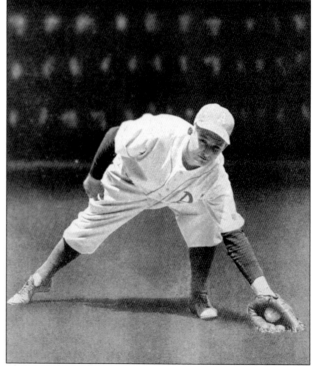

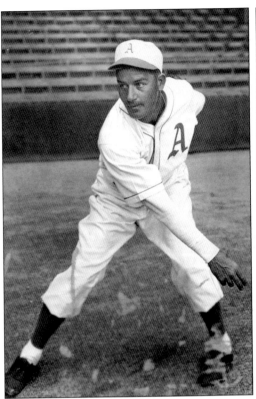

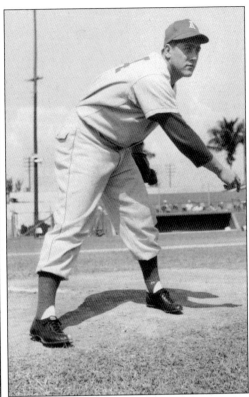

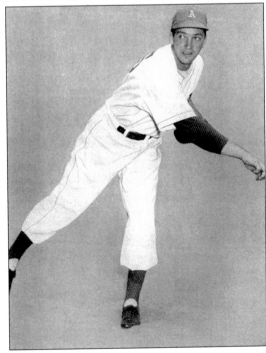

PITCHERS OF THE 1940s. Among the A's hurlers of the 1940s were Lum Harris (above left) whose 21 losses in 1943 were the most in the American League; Carl Scheib (above right) who became the youngest player to appear in a major league game, at 16 years, 8 months, and 5 days when he made his pro debut on September 6, 1943; and Dick Fowler (right) whose best performance came in 1947 when he posted a 12-11 record with a 2.81 ERA. (Philadelphia Athletics Historical Society.)

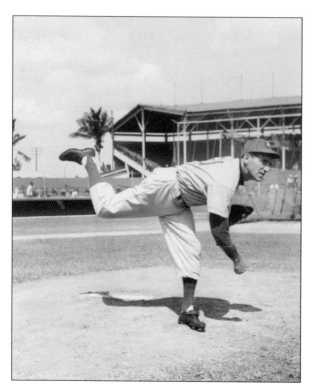

PHIL MARCHILDON. A native of Ontario, Canada, Phil Marchildon posted a 10-15 record with a 3.57 ERA in 1941, his rookie year with the A's. He improved to 17-14 the following year, before joining the Royal Canadian Air Force in World War II. Marchildon's plane was shot down over Germany in 1944, and he spent nine months as a POW. When he returned to the A's in 1945, he continued to be the bright spot on a mediocre pitching staff. In 1947, Marchildon went 19-9 and came within four outs of throwing a perfect game against Cleveland. (Philadelphia Athletics Historical Society.)

"BOBO" NEWSOM. A colorful, barrel-chested pitcher, Louis Norman Newsom spent 20 years in the major leagues. He called most of his teammates "Bobo" because he couldn't remember their names. His first tour of duty with the A's came in 1944 to 1946 when he posted a cumulative record of 24-40. After brief stints with the Senators, Yankees, and Giants, Newsom returned to Philadelphia to finish his career in 1952–1953, compiling a record of 5-4 during those final two seasons. (Philadelphia Athletics Historical Society.)

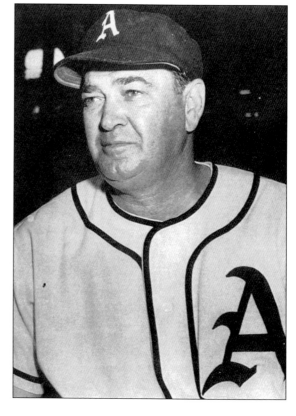

Seven

THE LONG GOODBYE:
1948–1954

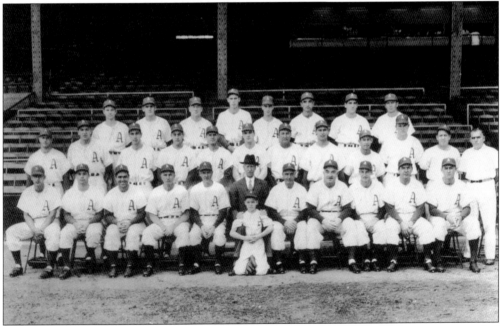

THE 1948 ATHLETICS. The 1948 season proved to be the A's swan song. The team contended for the pennant until the last few weeks of the season when injuries and poor relief pitching cost the club first place, and they finished fourth. Five years later, the team moved to Kansas City, putting an end to Philadelphia's most successful professional sports franchise. (Philadelphia Athletics Historical Society.)

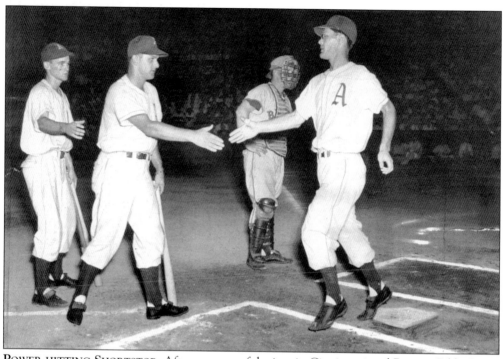

POWER-HITTING SHORTSTOP. After unsuccessful stints in Cincinnati and Boston, Eddie Joost, who had the reputation of being a troublemaker, went to the minors. In 1947, his career was resurrected by Connie Mack, who made Joost his regular shortstop and lead-off hitter. The following year Joost helped to put the A's in the thick of a pennant race. Here, Joost is greeted at home plate by Barney McCosky after hitting a lead-off homer. (Rich Westcott.)

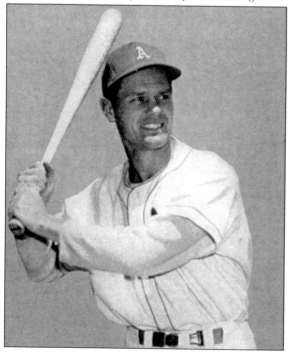

EDDIE JOOST. Joost, who came to Philadelphia at age 31, could still cover ground at shortstop and had a rifle arm. He led American League shortstops in put-outs four times to tie the league record and was an All-star in 1949. (Philadelphia Athletics Historical Society.)

VERSATILE PIVOT MAN. Second baseman Pete Suder teamed with Eddie Joost to set the major league single season record for double plays with 217 in 1949. (Philadelphia Athletics Historical Society.)

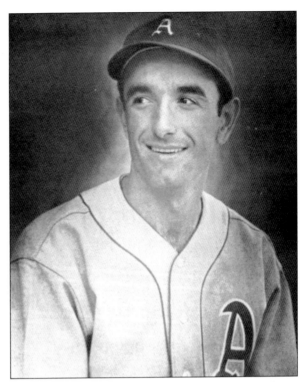

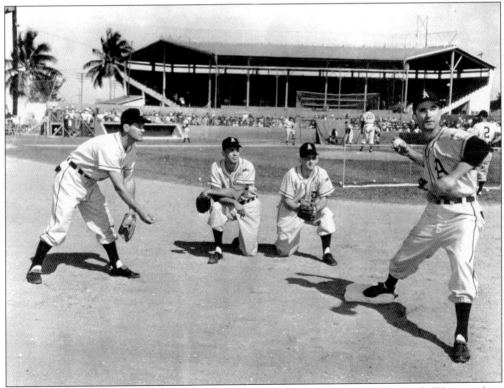

KEYSTONE COMBO. Joost and Suder turn a double play in spring training. (Rich Westcott.)

FERRIS FAIN. The first baseman on the Joost-Suder-Fain double play combination of the late 1940s was Ferris Fain. Considered the best fielding first baseman in the American League until Vic Power came up, Fain led the league four times in assists and twice each in total chances per game and double plays. Known as "Burrhead" because of his short-cropped hair, Fain won American League batting titles in 1951 and 1952 when he hit .344 and .327 respectively. (Philadelphia Athletics Historical Society.)

NELLIE FOX. Hall of Fame second baseman Nellie Fox began his major league career with the A's. After an unimpressive 1949 rookie season in which he hit only .255, the A's traded him to the Chicago White Sox. In Chicago, Fox became a reliable .300 hitter and established a record for consecutive games at second base, playing 798 straight. In 1959, when the Sox won their first pennant in 40 years, Fox was the American League's most valuable player. (Philadelphia Athletics Historical Society.)

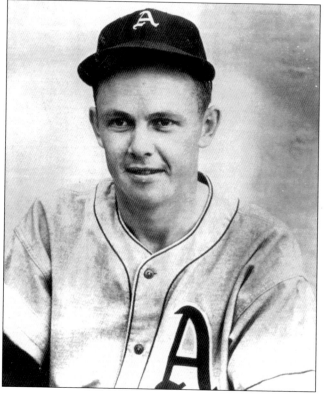

HANK MAJESKI. Connie Mack purchased Hank Majeski from the Yankees in 1946. From 1947 to 1951, Majeski was one of the top American League third basemen. His .998 fielding percentage for 1947 set a major league record. Majeski's best season came in 1948 when he hit .310 and knocked in 120 runs. (Philadelphia Athletics Historical Society.)

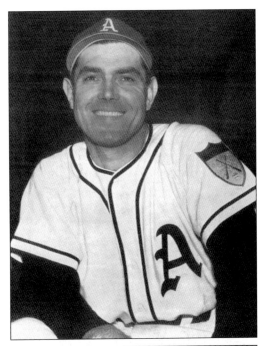

THE MACK MEN, 1950. By the late 1940s, control and ownership of the Athletics was divided equally between Mack and his three sons, Roy (third from left), Earle (far right), and Connie Jr. (far left). Roy and Earle's desire to implement their own plans led to tensions between them and their father. Faced with a weak and unprofitable team and poor health, Mack, in 1950, issued his eldest sons an edict—buy him out or sell out to him and Connie Jr. When the brothers chose to buy him out, they ended their 87-year-old father's baseball career, forcing him to retire. (National Baseball Hall of Fame.)

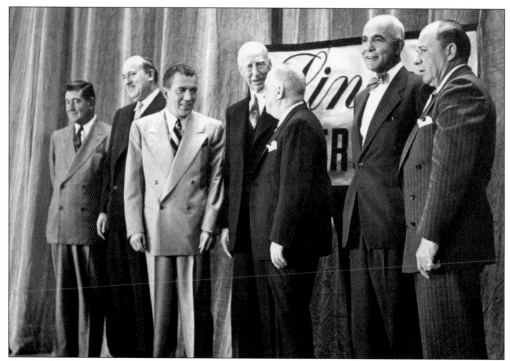

CONNIE MACK'S SWAN SONG. On October 18, 1950, the elderly Mack retired from baseball with the words "I'm not quitting because I'm getting old, I'm quitting because I think people want me to." But that still did not stop Mack from appearing on the *Ed Sullivan Show* (above) with new manager Jimmy Dykes (far right) and former players Mickey Cochrane (far left) and Bing Miller (second from right). Sullivan (third from left) began his career as a Philadelphia sportswriter before becoming a television variety show host. (Charles Burkhardt.)

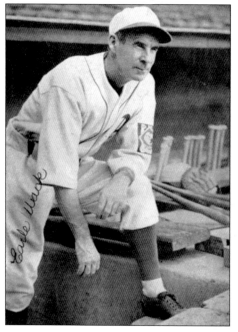

HEIR NOT-SO-APPARENT. For years Earle Mack had been the on-the-field assistant to his father and heir apparent to the manager's job. But the A's players did not respect his baseball ability. During the 1950 golden jubilee season, Earle was replaced as assistant manager by Jimmy Dykes and made chief scout of the organization. (Philadelphia Athletics Historical Society.)

MANAGER DYKES. After the 1950 season, Connie Mack stepped down as manager but retained the title of president of the club. Jimmy Dykes would manage the A's for the next three years. But with "no money to plug holes" in the lineup and "no bench strength," the best Dykes could do was fourth place in 1952. (Philadelphia Athletics Historical Society.)

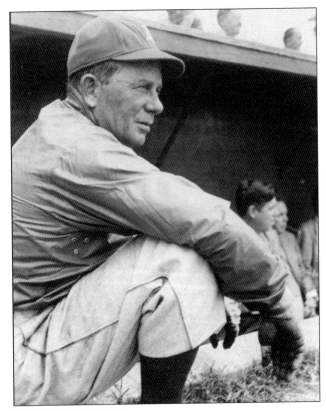

BOBBY SHANTZ. Connie Mack was not predisposed to small pitchers like the five-foot six-inch Bobby Shantz. But under Dykes's tutelage, Shantz blossomed. In 1951, he went 18-10 and learned how to change speeds effectively, mixing in a knuckler and curve with his fast ball. The following season Shantz went 24-7 for a fourth-place team and won the most valuable player award in a landslide. The remainder of his career in Philadelphia was injury-plagued and, in 1957, he was traded to the Yankees. (Philadelphia Athletics Historical Society.)

GUS ZERNIAL. During the 1950s, the 6-foot 3-inch, 210-pound Zernial was among the American League's most feared sluggers. Traded to the A's by the Chicago White Sox in 1951, Zernial went on to lead the league with 33 homers, 129 RBIs, and 17 outfield assists that year. In 1953, he hit another 42 home runs, just one shy of league leader Al Rosen. Though the fans loved "Ozark Ike," they also heckled him for his fielding deficiencies and the strikeouts that invariably came with his slugging feats. (Philadelphia Athletics Historical Society.)

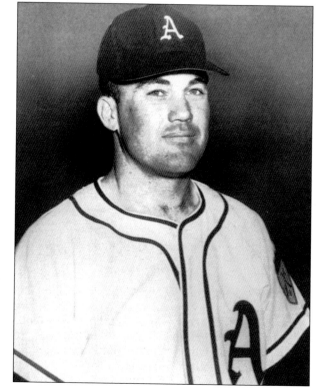

DAVE PHILLEY. An outfielder with excellent speed and a strong arm, Dave Philley spent three seasons with the A's (1951–1953). He became a journeyman after that, best known for his pinch hitting in the late 1950s. (Philadelphia Athletics Historical Society.)

JOE ASTROTH. One of only nine players to collect six RBIs in a single inning, Joe Astroth accomplished that remarkable feat on September 23, 1950. He was also Bobby Shantz's personal catcher during the hurler's most-valuable-player season of 1952. (Philadelphia Athletics Historical Society.)

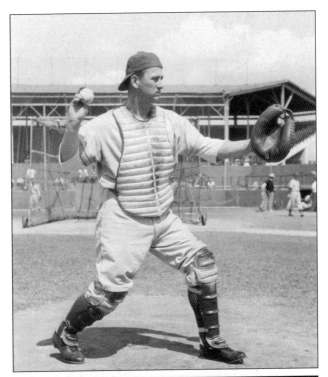

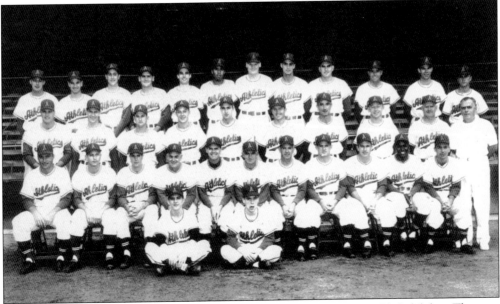

THE 1954 ATHLETICS. The 1954 Athletics were the last to perform in Philadelphia. The men pictured are, from left to right, as follows: (front row) Renna, Limmer, Ditmar, Hemsley (coach), Joost (manager), Moses (coach), Galan (coach), Robertson, McGhee, Power, and Jacobs; (middle row) Zernial, Bollweg, Astroth, DeMaestri, Billy Shantz, Valo, Suder, Finigan, McCrabb (coach), Tadley (trainer); (back row) Rozek, Fricano, Scheib, Kellner, Van Brabant, Trice, Wheat, Burtschy, Portocarrero, Martin, Upton, and Bobby Shantz. The two bat boys are unidentified. (Philadelphia Athletics Historical Society.)

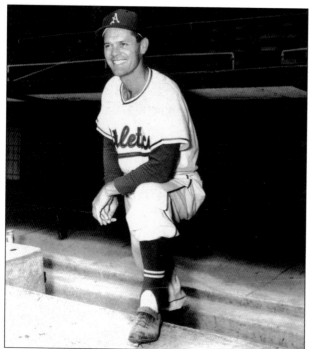

MANAGER JOOST. After the 1953 season, Roy and Earle Mack dismissed Dykes as A's manager and named shortstop Eddie Joost to take his place (left). Joost and his coaches, Augie Galan, Wally Moses, and Rollie Hemsley (below) inherited a poor team that lacked talent and competed for customers with the more successful Phillies. Predictably, the 1954 A's went 51-103, finishing in last place 60 games behind pennant-winning Cleveland. (Philadelphia Athletics Historical Society.)

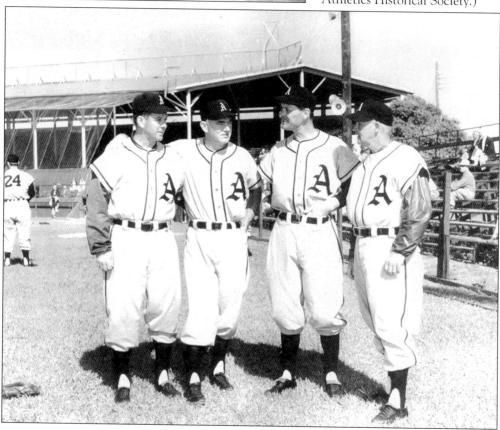

INTEGRATING THE A'S. The first African American player signed by the A's was pitcher Bob Trice, who came to the majors after winning 21 games at Ottawa in the International League in 1953. In 1954, he was 7-8 with a 5.60 ERA. When the A's moved to Kansas City in 1955, Trice appeared in only four games and never made it back to the big leagues. (Philadelphia Athletics Historical Society.)

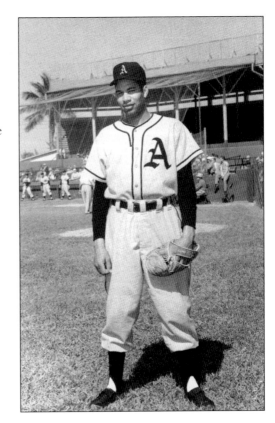

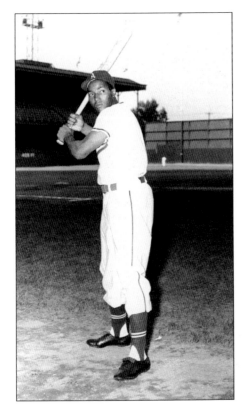

VIC POWER. After leading the American Association with a .349 batting average in 1953, Vic Power, a black Puerto Rican, joined Elston Howard as the first black players on the Yankees' roster. Inexplicably traded to the A's before the season began, Power was platooned in the outfield. He would blossom as a showboating first baseman when the team moved to Kansas City in 1955. (Philadelphia Athletics Historical Society.)

Selected Bibliography

Bevis, Charlie. *Mickey Cochrane: The Life of a Baseball Hall of Fame Catcher.* Jefferson, NC: McFarland, 1998.

Cobb, Ty, with Al Stump. *My Life in Baseball.* New York: Doubleday, 1961.

Daniel, W. Harrison. *Jimmie Foxx: The Life and Times of a Baseball Hall of Famer, 1907–1967.* Jefferson, NC: McFarland, 1996.

Jordan, David M. *The Athletics of Philadelphia. Connie Mack's White Elephants, 1901–1954.* Jefferson, NC: McFarland, 1999.

Kaplan, Jim. *Lefty Grove. American Original.* Cleveland, OH: Society for American Baseball Research, 2000.

Kashatus, William C. *Connie Mack's '29 Triumph: The Rise and Fall of the Philadelphia Athletics Dynasty.* Jefferson, NC: McFarland, 1999.

Kuklick, Bruce. *To Every Thing A Season: Shibe Park and Urban Philadelphia, 1909–1976.* Princeton: Princeton University Press, 1991.

Levy, Alan H. *Rube Waddell: The Zany, Brilliant Life of a Strikeout Artist.* Jefferson, NC: McFarland, 2000.

Lieb, Frederick G. *Connie Mack. Grand Old Man of Baseball.* New York: G.P. Putnam's Sons, 1945.

Mack, Connie. *Connie Mack's Baseball Book.* New York: Alfred A. Knopf, 1950.

Mack, Connie. *My 66 Years in the Big Leagues.* Philadelphia: John C. Winston Company, 1950.

Neyer, Rob and Eddie Epstein. *Baseball Dynasties. The Greatest Teams of All Time.* New York: W.W. Norton & Company, 2000.

Seymour, Harold. *Baseball: The Golden Age.* New York: Oxford University, 1971.

Shatzkin, Mike, editor. *The Ballplayers: Baseball's Ultimate Biographical Reference.* New York: William Morrow, 1990.

Werber, Bill, with C. Paul Rogers III. *Memories of a Ballplayer.* Cleveland: SABR, 2002.

Westcott, Rich. *Philadelphia's Old Ballparks.* Philadelphia: Temple University Press, 1996.

CONNIE MACK STATUE. The failure of the Mack family to keep up with the increasing costs of operating a modern sports franchise and their inability to compete for the city's fans with the wealthier, more successful Phillies resulted in the sale of the A's to Chicago businessman Arnold Johnson after the 1954 season and a move to Kansas City.

Connie Mack remained in Philadelphia. Occasionally, he attended Phillies games at the same ballpark in which he once managed his beloved A's. Only now, the park was renamed "Connie Mack Stadium" in his honor. On February 8, 1956, the Grand Old Man of Baseball died.

Twenty years later, the ballpark that bore his name was demolished, the Phillies having relocated to Veterans Stadium. Today, all that remains is a statue of Connie Mack waving his trademark scorecard, a poignant reminder of a manager and a baseball team that were among the greatest of all time. (The *Philadelphia Inquirer.*)